OKLAHOMA
SCOUNDRELS

OKLAHOMA SCOUNDRELS

HISTORY'S MOST NOTORIOUS
OUTLAWS, BANDITS & GANGSTERS

ROBERT BARR SMITH &
LAURENCE J. YADON

THE
History
PRESS

Published by The History Press
Charleston, SC
www.historypress.net

First published 2016

Manufactured in the United States

ISBN 978.1.46713.519.1

Library of Congress Control Number: 2016943513

Notice: The information in this book is true and complete to the best of our knowledge. It is offered without guarantee on the part of the authors or The History Press. The authors and The History Press disclaim all liability in connection with the use of this book.

CONTENTS

INTRODUCTION

The land we now call Oklahoma was wild and violent from its earliest days, from the creation of Indian Territory in 1830 as a refuge for the Indian tribes forced out of Tennessee, Georgia and Alabama. The Five Civilized Tribes, as the Cherokee, Choctaw, Chickasaw, Creek and Seminole tribes were eventually known, maintained no jails or prisons in the early years. Instead, justice generally followed two simple paths: whipping for minor offenses and a firing squad for the rest.

Their tribal justice systems at first relied on mounted police, called the Lighthorse. Over the vast expanse of Indian Territory, the Lighthorse not only investigated crime and made arrests but also appointed judges and juries and saw to punishment—all according to written rules. Save for occasional abuses, the system worked well. Except for one problem.

Tribal jurisdiction was very limited. A tribe's Lighthorse law officer—say, the Creek police—could arrest only members of his own tribe, adopted members and men of other tribes who had committed crimes within the Creek Nation. The jurisdiction of the United States was similarly complex: a deputy marshal could arrest only United States citizens. A marshal could apprehend an Indian only if the crime was against a U.S. citizens or involved alcohol (bootlegging being the perennial curse of the territory).

Early on, federal officers were largely limited to serving arrest warrants from the District Court in Fort Smith and returning prisoners to that busy tribunal. Unless reward money was available, the officers were paid only a puny per diem; they got nothing at all for a bad man killed resisting arrest.

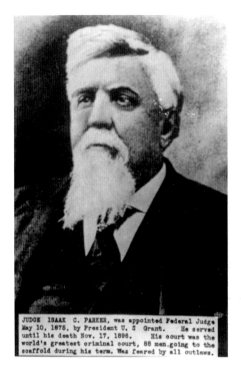

JUDGE ISAAK C. PARKER, was appointed Federal Judge May 10, 1875, by President U. S Grant. He served until his death Nov. 17, 1896. His court was the world's greatest criminal court, 88 men.going to the scaffold during his term. Was feared by all outlaws.

"Hanging Judge" Isaac Parker. *Western History Collections, University of Oklahoma Libraries.*

The two systems sometimes clashed. The worst conflict came in 1872 near the Arkansas border at Going Snake Schoolhouse, then being used as a temporary tribal courthouse. U.S. officers tried to arrest the defendant, the court objected and the resulting shootout with court personnel, spectators and even the defendant left at least ten men dead and the defendant on the run.

Three years later, Judge Isaac Parker was appointed to the federal bench in Fort Smith, a huge jurisdiction about the size of New England. Parker was then, and later, called the "Hanging Judge." Some would say, "Not hardly." A good man and a fine judge, in twenty-one years he tried a prodigious number of cases: more than 13,000. About 9,500 were convicted, and just 106 were sentenced to hang. Only 79 actually did.

The men who brought evildoers back for trial were at least as tough as the worst of their quarry. These included the "three guardsmen," Heck Thomas, Bill Tilghman and Chris Madsen; big Bass Reeves, the first black deputy east of the Mississippi; Bud Ledbetter; and Frank Canton, who started as Texas cattle rustler and bank robber Joe Horner.

When the Muskogee (Creek) Nation was forced to abandon eastern tribal lands after 1826, the tiny settlement called Tulsey-Town was on the new tribal ground. Within a year, the Creek leaders had established a ceremonial town on a hill high above the Arkansas River, beneath a massive tree that still stands. It's called the Council Oak, and a second tree, still standing not far away, became a gallows—at least three rustlers died on it. For a time, the young town was a haven for outlaws, who, as one tale says, "if they spotted no mount from their lookout" on a nearby hill, "boldly walked Tulsa's streets, ate at its cafés and traded at its stores. ...Typical purchases included suspicious amounts of gunpowder and ammunition."

INTRODUCTION

About the same time a Tulsa area murderer named Childers was ushered off this earth by Judge Parker, Tulsa had its first gunfight, a battle between city marshal Tom Stufflebeam and one Texas Jack, just one of a rich assortment of felons who haunted the area. Notable among them were Dick Glass, who sported a homemade bulletproof vest, and Wes Barnett, who tried to kill Creek chief L.C. Perryman and almost succeeded. It is said that Grat Dalton got into trouble in Tulsa shooting apples from citizens' heads. Grat was drunk, of course, but that was nothing unusual for him. It was a tough town in a tough area. Somebody figured that between the Revolutionary War and the year 2000, over 40 percent of all U.S. deputy marshals who died in the line of duty were killed in what is now Oklahoma. And of course, outlaws who were that only in legend abound to this day. Take, for example, Annie McDoulet (or McDougal) and Jennie Stevensen (or Stevens), known to history as "Cattle Annie and Little Britches," two teenage girls who supposedly were part of the notorious Bill Doolin gang. In fact, there is no documentation that Annie or Jennie engaged in anything more than minor thefts and bootlegging.

In contrast, the chapters to come chronicle the deeds and misdeeds of some of the worst outlaws in Oklahoma, plus a few of the truly inept, like bumbling Al Jennings. Al tried the owl hoot trail, was a miserable failure and spent some time in jail. He later became a politician, which some cynics would call a similar profession—only with clean sheets.

Four years after Judge Parker took his seat on the bench in Fort Smith, Tulsa got its very own post office, and in 1882, the grandly named St. Louis and San Francisco Railroad—in common parlance, simply "the Frisco"—arrived. The iron horse was critical to the survival of any frontier town, especially a settlement like Tulsa, which depended heavily on cattle. The next year, Fort Smith hanged its first malefactor, one John Childers. There would be plenty more, but as Robert Barr Smith tells us in the first chapter, Belle Starr wouldn't be one of them.

1
BELLE STARR

A LEGEND IN HER OWN MIND

Back before television, kids read books, played ball or went to the movies. Ah, the silver screen! Movies were cheap—especially if you were a kid—and a big bag of popcorn cost only a nickel. Invariably—at least during Saturday matinees—you got to watch a double feature, plus an installment or two of Buck Rogers, a newsreel, the previews, one or two episodes of the Road Runner outwitting Wile E. Coyote, sometimes a travelogue and the ads for the local Chevy dealer and the plumber and whoever else your folks might need locally. You got a whole lot of entertainment for thirty cents, and you got to sit with your friends.

One end of the double feature was sure to be a western; sometimes both, if you were lucky. That's where we learned all about the Old West, or at least we thought we did. All of us kids figured the singing cowboys—Gene Autry and his like—were phony, but the others looked real. We learned of a lot of history (we thought) from the heroics of Lash Larue and Randolph Scott and other straight-shooters. Youthful dreams don't die easily, and it took me a lot of years to learn that a lot of what I saw in the matinees was hogwash.

One of my most precious memories was of Belle Starr, played by Gene Tierney, by any standard one of the loveliest women ever to appear in film. In the minds of us kids, Gene was Belle Starr, the Bandit Queen, the leader of a daring gang, galloping about the countryside without, of course, a hair out of place. Back in the '40s, I discovered Belle/Gene, and I think I fell in love immediately.

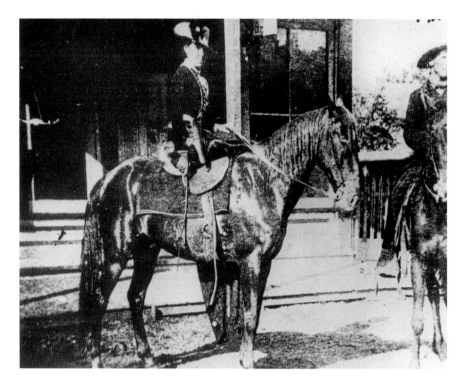

Belle Starr—big horse, big pistol. *Western History Collections, University of Oklahoma Libraries.*

Sadly, as I got older and found out what Belle was really like, another treasured illusion vanished forever. It was sad to learn that Belle was hardly the Bandit Queen. On her best days, she was a small-time horse thief, a sort of criminal moll who cast a long shadow with very little substance behind it, something like the Wizard of Oz. Physically, she was no rival to Gene Tierney to start with, but as the years went by, she gradually morphed from reasonably pretty girl to truly ugly harridan, the kind of woman westerners would say had been "rid hard and put away wet."

Still, her legend is far too solidly established to ever pass away. And in fact, she had much to do with real outlaws in her time, not the least of whom was her father-in-law, the formidable Old Tom Starr. And she married a couple other outlaws, too, both of whom died of terminal lead poisoning. And according to legend, Belle dallied with an assortment of other hard cases along the way. That includes Cole Younger, who, western legend says, fathered her daughter, Pearl, something Cole denied to his dying day. And in this, at least, Cole was probably telling the truth.

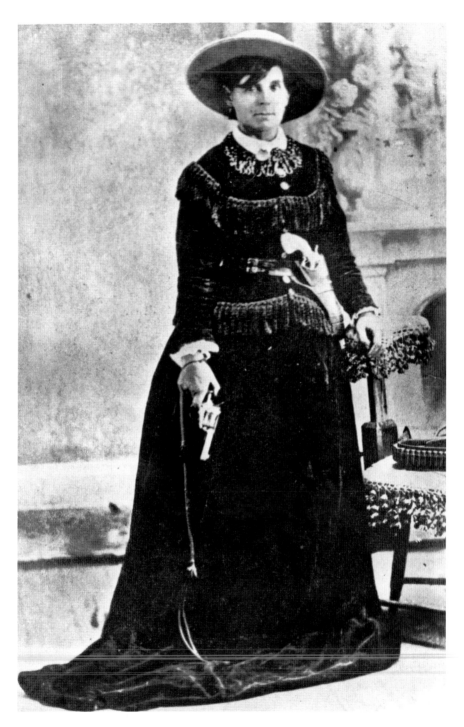

Belle, armed to the teeth. *Western History Collections, University of Oklahoma Libraries.*

Still, Belle has probably inspired as much mythology as any other outlaw in the history of the West, which is saying rather a lot. Part of her legend is that she was Cherokee (she wasn't), that she had Cole Younger's child (no, she didn't) and that she galloped about carrying messages for Missouri guerrillas during the Civil War (probably not).

Still, since Belle lived in a time when any sort of female outlaw was a sensation, some of the florid prose about her reached epic proportions. For example, this marvelous drivel written by "Captain Kit Dalton":

> *A more winning smile never illumined the face of a Madonna; a more cruel human never walked the deck of a pirate ship…this phenomenally beautiful half savage…a maroon Diana in the chase, a Venus in beauty, a Minerva in Wisdom.*

What a woman! What a criminal mastermind!

What nonsense!

A similar bit of hyperbole appeared in something called *Remarkable Rogues: The Careers of Some Notable Criminals in Europe and America*. This fairy tale titillates and horrifies the reader with the revelation that, at fifteen, Belle killed her first man, a camp robber, strangling him "with her small white hands."

In S.W. Harman's *Hell on the Border*, Belle is "a sure shot and a murderess," and "of all the noted women ever mentioned by word or pen, none have been more brilliantly daring nor more effective in their chosen roles than Belle Starr, champion and leader of robbers."

Many years later, even some old-timers in Indian Territory spun fanciful tales of Belle. One of them went like this:

> *I remember one time the law was after Belle and she stopped at a Negro cabin; she made the Negro woman hide her. She dressed up in a black dress with a white apron and shawl, blacked her face, and when the law came in she was rocking in a chair with a cob pipe in her mouth.*

That fable, like the others, is about as believable as one of the tales of Mother Goose, but it was only one of the bizarre stories told of the Bandit Queen. In fact, the truth is at once stranger and more prosaic.

Belle was a Missouri girl, born plain old Myra Maybelle Shirley on a farm up near Carthage, Missouri. That was in 1848, and Belle's father was a successful man in that year and a slaveholder. Myra Maybelle—if a picture purporting to be the lass in fact is her—was quite attractive in those far-

off days. Then came the horrors of the Civil War, casting their long, ugly shadow across the land, and all of the peaceful life changed. The family was then living in the town of Carthage, where Myra Maybelle got an education at the Carthage Female Academy.

The stories about her tell that she received something most girls did not—an excellent education for the time, including foreign languages—and also became an accomplished musician. Her father was still prospering, now in the innkeeping business, but the war would largely ruin him just as it destroyed so many others.

His eldest son, Bud Shirley, joined a band of Missouri bushwhackers and was killed, and the town of Carthage was burned. There are all sorts of stories about young Belle's heroics during the war, "fired to deeds of valor" by "her hot Southern blood," as one sensational writer put it. Legend even has Belle galloping about the countryside carrying messages for her brother's guerrilla band or even acting as a spy. She was "frequently with Cole Younger and the James boys," the story goes, even though the Younger brothers and the James boys rode with different guerrilla units.

With Bud's death and the loss of much of his property, the senior Shirley had enough of the vicious border war and moved his family south, settling near the town of Scyene, Texas, now a part of Dallas. Belle grew to womanhood there and, in 1866, married a hoodlum called Jim Reed, who was already on the run from the law. Two years later, a daughter appeared and was named Rosie. Belle called the girl "her pearl," however, and Pearl she remained for the rest of her days. Pearl would grow up to a sort of eminence as both prostitute and madam, but that was far in the future.

The Reeds lived for a while under the protection of tough Old Tom Starr, on his spread down on the Canadian River in Indian Territory. However, in 1871, they were living in California, where their son Ed was born. Reed was a professional criminal and by this time was wanted for murder. There are tales that Belle was his confederate in crime, at least to the point of fencing horses her husband had stolen. The legends about her robbing and murdering—which have no solid foundation—are probably no more than a part of the mythology surrounding Belle's life.

One major source of the undying myth about Belle and her "gang" is S.W. Harman's *Hell on the Border*, a rousing book purporting to be a history of Judge Parker's court at Fort Smith. Belle, Harman says, collected a set of "admirers as reckless as herself," each becoming her lover, according to Harman, seriatim. These adoring desperados, according to Harmon, included Jim French, Jack Spaniard and Blue Duck, all truly nasty pieces

of work. These hard cases "stood ready to obey the woman they admired yet feared, who could out ride, out jump and out shoot them all, who could draw her pistol from its convenient holster at her side in a twinkling and who never missed a mark."

And so forth.

Two 1874 incidents are probably the best known of her so-called outlaw career. The first was the robbery of the San Antonio–Austin stagecoach. There is no real evidence that Belle had anything to do with the crime, let alone that she was part of the holdup itself. The second crime in which Belle is supposed to have played a part was Jim Reed's robbery of a wealthy Indian, stealing a purported $30,000, an enormous sum of money for the time.

It was an especially nasty crime. The victim, Watt Grayson, at first refused to tell Reed and two other bandits where he kept his cash. They then threw a noose around Grayson's neck and hoisted him clear of the ground until he nearly strangled. When this cruelty produced no result, his tormentors turned on Grayson's wife and began the same torture.

Grayson was plenty tough, but he would not let his wife suffer, so the bandits got his money. Again, there is no real evidence that Belle was even present, although her husband Jim Reed probably was part of the robber gang.

Reed lasted until the summer of 1874, when he came in second in a Paris, Texas gunfight with a deputy. There is a charming tale that Belle refused to identify what was left of Reed in order to deny the officer the reward carried on Reed's head. Nice story but again without foundation. Belle was now a widow, but being Belle, she wouldn't remain that way for long.

She is said to have dallied with Bruce Younger up in southern Kansas, maybe even marrying him, but whatever the relationship was, if any, it did not last. And then, in the summer of 1880, she married Sam Starr down in the Cherokee Nation. Sam was the son of Old Tom Starr, one of the really ferocious fighting men of the territory, and the couple settled on his property.

Somewhere along the way, Old Tom's spread came to be called Younger's Bend, which produced still another legend: that Belle named the place, still carrying a torch for Cole Younger who, according to legend, was the father of her Pearl. This seems to be no more than yet another folk myth, for the place was named by Old Tom himself, who apparently entertained some admiration for the Missouri outlaw.

In 1883, Belle and her new husband did a short stretch at the Detroit House of Correction for horse stealing, but when their time was up, they returned to Younger's Bend. And then, in 1886, Sam Starr ran into a hated adversary, one Frank West, while attending a dance. The two wasted no

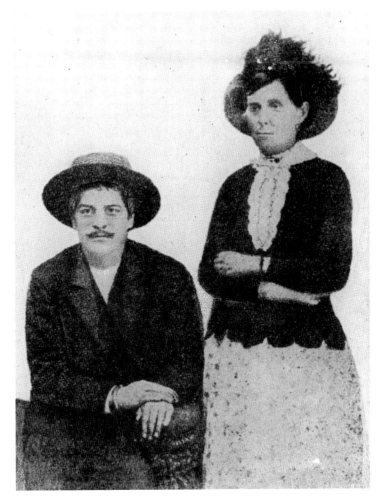

Belle Starr with lover Blue Duck. *Western History Collections, University of Oklahoma Libraries.*

time in reaching for their guns, and in a few minutes, both men were dead. That was probably a good thing for the general population, but Belle was once more a widow.

Here the mists of mythology close in again. Belle was moved to continue her budding career as bedfellow to various disreputable outlaw types, although it's not entirely clear who all her lovers might have been. She is quoted as having said, "I am a friend to any brave and gallant outlaw," and sure enough, she was. She was more than a friend to a whole passel of outlaws, if legend is anywhere near accurate. A host of stories has her

cavorting with a veritable who's who of luminaries in the local outlaw world, including—at least—Jack Spaniard, Jim French, Jim July (who ended up calling himself Jim Starr) and a man much younger than the now-aging Belle, one Blue Duck.

Although Belle was no longer a ravishing beauty—if she ever was—she seems to have carried on with her bed-hopping career. When she wasn't so engaged, she still indulged in her second passion for having her picture taken à la outlaw, armed with at least one gun and sometimes posed on a very tall horse.

Whatever carnal delights Belle may have indulged in, she also paid attention to her home at Younger's Bend. And that was probably what ended her life prematurely. For she had at least one sharecropper tenant: a thoroughly worthless criminal called Ed Watson. He had come out of Arkansas but was originally from Florida, where he was wanted for murder, among other things. Belle seems to have found out about Ed's nasty past—and it was too much knowledge for her health.

Belle and Watson had a major falling out when Belle, afraid of more trouble with the authorities if she were discovered harboring a fugitive, told Watson to leave her land and sent him a letter returning his rent money. The two argued, and Belle made the mistake of telling the man that while federal marshals might not be interested in him, "the Florida officers might." It was an unwise thing to say. Although others were suspected as her killers then and afterward—including her own son—it seems pretty clear that a furious Watson determined to close Belle's mouth forever about his dirty career in Florida.

Either Watson or somebody else waylaid her and blew her out of the saddle with a shotgun. And so, in February 1889, Belle passed to her reward, whatever that might be. She was buried at Younger's Bend, according to legend, with a revolver in her hand. The myth was off to a good start.

Watson was charged but never tried. There simply was not enough evidence against him to empanel a jury. But knowing that Jim July Starr would almost certainly try to kill him, Watson left the state and at last ended up back in Florida, where he went on killing, running up a tally of as many as ten or twelve people. In time, he ran afoul of some tough peace officers who filled him full of holes.

Meanwhile, in December 1896, Belle's son, Ed Reed, got full of tarantula juice in a saloon run by a man named Tom Clark. Reed got rowdy and began "brandishing his six shooter in a very careless way and abusing the bystanders and shooting up the place generally," as the *Muskogee Phoenix*

matter-of-factly put it. Clark was understandably upset, and some hard words passed between the men. Reed left but came back with a Winchester and threatened Clark. It turned out to be a bad idea, for Clark was quicker and shot Reed twice, whereof he expired.

As for Belle's "Pearl," she carried on with her prostitute/madam career. Finally exiled from Fort Smith after repeated arrests, she drifted west, dying in an Arizona hotel in the summer of 1925.

It was just as well that Belle was not around to see the end of her children, but she sure would have enjoyed Gene Tierney's sterling performance.

2
THE DALTONS

A LOVELY AUTUMN DAY
IN KANSAS

They rode in through a brilliant October morning in 1892, laughing together and "baaing" at the sheep and goats in the fields along their way. They seemed to be out on a casual ride; instead, they planned to rob two banks in the pleasant little town of Coffeyville, Kansas, and kill anybody who got in their way.

Three of the young men were brothers named Dalton, and they knew Coffeyville, for the Dalton family had lived nearby for several years. They were going to do what they thought nobody had ever done before: rob two banks at once. In the main square of the town stood the Condon and First National. The citizens were peaceful people. It should be a piece of cake. Nobody in town even carried a gun anymore, not even the temporary town marshal, who in any case was a school principal by profession.

This strike was going to be a big one, and it would finance their exodus from Kansas and Indian Territory, where the law wanted them badly. Tough deputy U.S. marshal Heck Thomas was on their back trail, only a day or so behind them, for during their last holdup at Adair, down in the territory, they had shot down a couple of unarmed, inoffensive civilians as they galloped out of town. Worse, both the men they had shot were doctors—a jealously protected species in the West—and one of their victims was dead.

Two banks at once was a feat never equaled even by the Dalton boys' famous cousins, the Younger brothers, now languishing in a Minnesota prison, much less by the Youngers' boon companions, Frank and Jesse James.

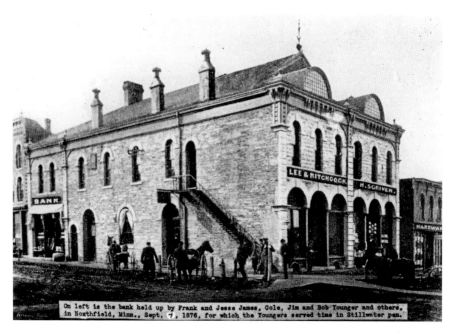

First National Bank, Northfield, Minnesota. *Western History Collections, University of Oklahoma Libraries.*

"Death Alley," Coffeyville. *Western History Collections, University of Oklahoma Libraries.*

Coffeyville was wholly unprepared for a raid from the most notorious outlaw gang of the day still on the loose. The gang might have gotten away with stealing the citizens' savings—except for Coffeyville's penchant for civic

improvement. For the town was paving some of its downtown streets and had moved the hitching rack to which the gang had planned to tether their all-important horses. Since the gang had done no reconnaissance whatsoever, this came as a complete surprise. "Well I'll be damned," said Bob Dalton somewhat unnecessarily. "They've taken down the rack."

So they rode around the busy streets until they found a spot to park their mounts in an alley, behind the police judge's house. They tied the horses to a fence in the alley—it's called "Death Alley" today—and walked together down toward the square, five dusty men carrying Winchesters in a peaceful town where the Daltons were known and nobody else carried a weapon. They were immediately spotted by at least one citizen who knew the family, and the word spread quickly.

They crossed the open plaza and walked into the two unsuspecting banks. Tall, handsome Bob Dalton was the leader, a reasonably bright man with a fearsome reputation as a rifleman. Grat, the eldest, was a slow-witted thug whose avocations were beating on other people, gambling and sopping up prodigious amounts of liquor. As writer Harold Preece put it, "Grat had the heft of a bull calf and the disposition of a baby rattlesnake."

Emmett, or "Em," was the baby of the lot, only twenty-one on the day of the raid but already a seasoned robber. Backing the Dalton boys were two more experienced outlaws, Dick Broadwell and Bill Powers. Powers was a Texas boy who had punched cows down on the Cimarron before he decided robbing people was easier than working. Broadwell, scion of a good Kansas family, allegedly turned bad after a young lady stole both his heart and his bankroll and left him flat in Fort Worth. Perhaps because he was reluctant to split the expected booty more than five ways, Bob left behind several veteran gang members, like Bill Doolin, Bittercreek Newcomb and Charlie Pierce.

Grat Dalton led Powers and Broadwell into the Condon Bank. Em and Bob went on across the street to the First National. Inside, they threw down on customers and employees and began to direct the bank men to deliver the banks' money and be damn quick about it. Next door to the First National was Isham's Hardware, which looked out on the front door of the Condon, into the Plaza and thence down Death Alley to where the gang left its horses, three hundred feet or more away. Isham's and another hardware store started handing out weapons to anybody who wanted them, and there were over a dozen takers.

Inside the First National, Bob and Emmet had gotten a sackful of cash, in spite of the bankers dragging their feet. The brothers finished up their

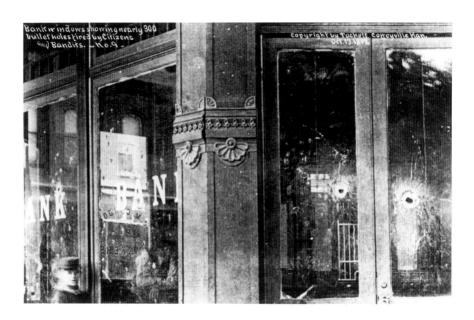

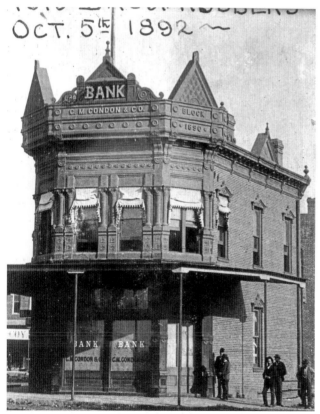

Above: Condon Bank, Coffeyville, with windows full of bullet holes. *Western History Collections, University of Oklahoma Libraries.*

Left: Condon Bank, Coffeyville, as it is and was. *Western History Collections, University of Oklahoma Libraries.*

looting, collected some hostages, pushed out the door into the Plaza—and then all hell broke loose in Coffeyville.

The first shots were fired at Emmett and Bob, who dove back into the First National. Bob shot one citizen through the hand, and then he and his brother ran out the back door. The two kept going, circling around through a side street, out of sight of the waiting citizens, along the way killing a young store clerk. Bob was ready, he told his brother, to do the fighting. Emmett's job was to carry their loot in the grain sack that was standard equipment for the robbers of the day.

Inside the Condon Bank, Grat had collected a sackful of silver so heavy that it would take more than one man to carry it. Then, when he demanded the vault be opened, courteous young Charley Ball looked Grat in the eye and blandly announced that the time lock to the vault (long since opened) would not unlock for several minutes. "Eight minutes," crowed a later newspaper report, "was the time consumed by Cashier Ball in his one-act skit of 'the Bogus Time Lock.'"

That eight minutes saved the bank treasure and cost the Dalton gang its existence.

While Ball courageously sold gullible Grat Dalton on this colossal fib, another employee helpfully rattled the vault doors to complete the illusion. He didn't pull on them, of course, because they would have swung open.

Grat, instead of trying those doors himself, stood and waited for the hands of the clock to move, while outside the townsmen loaded Winchesters and found cover. About the time thick-headed Grat began to suspect that he was being had by Charlie Ball's honeyed words, somebody outside fired a shot. Hell in Coffeyville was in session. A pair of house painters bailed off their scaffolding and hit the ground running, women shooed their children indoors and the gathering of defenders over at Isham's opened up. One especially courageous soul even crawled out on a porch roof and began popping away with a pistol.

Bullets began to punch through the windows of the Condon Bank; one tore into Broadwell's left arm. "I'm hit!" he yelled. "I can't use my arm!" Grat, Broadwell and Powers could not match the firepower of the citizens, as some two hundred projectiles of various sizes slammed into the windows and façade of the Condon. One defender at Isham's was hit in the chest by a rifle round and knocked flat—but all he got from the outlaw bullet was a bruised chest, for the slug had hit an iron spanner (wrench) he carried in his shirt pocket.

The townsmen's heavy, accurate fire convinced even dull-witted Grat that maybe it was high time to go. Leaving behind their enormous heap of coin,

the three outlaws charged out into the bullet-swept Plaza, straight into the line of fire of the rifles at the hardware store, running hard for their horses, now so very far away down the alley. There was no cover for them anywhere, and they were being shot at not only by the citizens in the hardware store but also by men firing from the offices upstairs in the Condon.

They didn't have to run that impossible gauntlet. Grat could have led his men around the corner on which the bank sat. Had he done so, they would have been out of the line of fire from Isham's in just a couple of strides. Or he could have sought the bank's back door. Instead, Grat led his men out into the plaza in front of the bank, directly into the killing zone, running hard for the alley and snapping shots at that deadly nest of rifles inside Isham's Hardware. All three outlaws were hit before they reached their horses. Witnesses saw dust puff from their clothing as rifle bullets tore into them.

Meanwhile, Bob and Emmett ran out of the First National, down the alley behind the bank and around a block, staying out of the defenders' sight. They came in behind some townsmen still facing down the street toward the First National and the Condon, and Bob shot down a shoemaker armed with a rifle. An old Civil War veteran who was now a cobbler courageously reached for the fallen man's weapon, and Bob killed him, too. Bob drove a round through the cheek of still another citizen as the outlaw brothers ran on, trying to reach Grat and the all-important horses.

They kept buildings between them and those deadly rifles and emerged in the alley about the time Grat and the others got there. About the same time, town marshal Charles Connelly appeared in the alley from another direction but miscalculated the position of the fleeing outlaws and came in between them and their horses. Grat Dalton, already wounded, shot the lawman down from behind. Liveryman John Kloehr, the town's most expert shot, then put Grat down for good with a bullet in the neck.

As Bob and Grat ran into the alley, somebody—or several somebodies—nailed Bob Dalton, who sat down on a pile of cobblestones. Still game, he went on working his Winchester for several aimless shots, one of which tore into a box of dynamite over at Isham's—without effect. Kloehr drove a bullet into Bob's chest, and the outlaw leader slumped over on his side and died in the alley. Powers lay dead in the dust about ten feet away.

Broadwell, mortally wounded, managed to get to his horse. He rode about a half mile toward safety before he pitched out of his saddle, dead in the road. Young Emmett, still carrying the grain sack of loot from the First National, miraculously managed to get mounted. Hit several times in

Bob (left) and Grat Dalton, finished in Coffeyville. *Western History Collections, University of Oklahoma Libraries.*

quick succession, he jerked his horse back into the teeth of the citizens' fire, reaching down from the saddle for his dead or dying brother Bob. There's a good deal of mythology about Bob's last words to his brother: "Don't surrender. Die game!" Or maybe Bob said something similarly heroic, as Emmett, never renowned for slavish adherence to the truth, claimed decades later. Or maybe Bob said nothing at all.

About then, the town barber, Carey Seaman, blew Emmett out of the saddle with both barrels of his shotgun.

Four citizens were dead. Three more were wounded. The man with a rifle slug through one cheek was hurt very seriously indeed and at first was expected to die. Four bandits had also died, and Emmett was punched full of holes—more than twenty of them. He was carried up to the second-floor office of Dr. Wells, who set out to save the young outlaw's life.

While the doctor was at work, a group of citizens, understandably angry at the death of four of their friends, appeared in the doctor's office carrying a rope. They planned to tie one end to a telegraph pole outside the doctor's window and the other end to Emmett and then throw him out the window. "No use, boys," said the doctor. "He will die anyway." One citizen spoke up. "Are you sure, Doc?" "Hell, yes," said Dr. Wells. "Did you ever hear of a patient of mine getting well?" That broke the tension, somebody laughed and Emmett was saved for trial and a long spell in the Kansas state penitentiary.

The four expired bandits were propped up to have their pictures taken after the custom of the time, and people came from everywhere to see the corpses and collect souvenirs: bits of bloody clothing, hairs from the dead horses and so on. Some brought their kids, thinking that the edifying sight of dead bandits might be helpful in keeping the young on the straight and narrow. Some sightseers indulged in a macabre hydraulics experiment; if

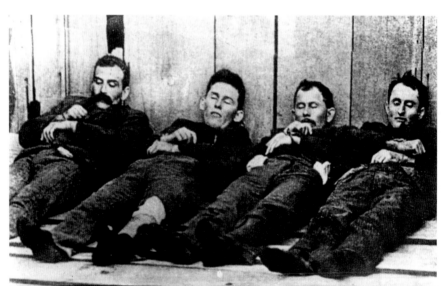

Left to right: Bill Powers, Bob Dalton, Grat Dalton, Dick Broadwell, four of the five men killed, when they attempted to rob two banks, at Coffeyville, Kansas, Oct. 5, 1892. Emmett Dalton, who was with them survived 21 bullet wounds, served time in penitentiary until pardoned. Has written articles that "Crime Does Not Pay."

Dalton Gang, end of the trail, Coffeyville. *Western History Collections, University of Oklahoma Libraries.*

you worked Grat's arm up and down like a pump handle, blood squirted out of the hole in his throat.

And so passed the Daltons in one of the most famous and badly planned and executed holdups in the history of crime. Bob and Grat are still in Coffeyville, up in the cemetery. They have a headstone these days, but planted alongside it is a piece of ordinary pipe, long their only monument and still the most enduring one.

It's the pipe to which they tied their horses in that deadly Coffeyville alley.

3
BILL DOOLIN

GUNFIGHT AT THE OK HOTEL

There wasn't much to look at or do in Ingalls, Oklahoma Territory, that Friday morning, September 1, 1893, five months after Bill Doolin had married a local girl. And even today, only an aging historical marker and a ramshackle replica structure or two commemorate the place. Yet that

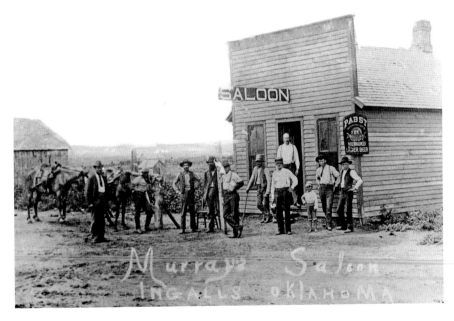

Outlaw Roost, Ransome and Murray Saloon, Ingalls, Oklahoma Territory. *Western History Collections, University of Oklahoma Libraries.*

morning, 123 years ago, one innocent bystander was mortally wounded, and three lawmen and a young man were killed by the notorious Bill Doolin gang, all of whom escaped save one.

The Ingalls Battle, September 1, 1893

Bill Dalton, Dan "Dynamite Dick" Clifton, William "Tulsa Jack" Blake and Doolin himself were playing cards that morning in a one-story shack called the Ransom Saloon. Their business associate Bitter Creek Newcomb went out in the street to check on their horses, only to see a young boy named Del Simmons point him out to a stranger nearby. And the stranger, deputy U.S. marshal Dick Speed, wasn't in town for the bad liquor and worse food.

The feds had learned the previous day that the Doolins were in Ingalls and put together two wagons full of law enforcement officers and posse members to round them up. Jim Masterson, brother of noted gunfighter and Wyatt Earp compadre Bat Masterson, hurried out of nearby Stillwater at sunset the previous evening with four other deputies even as a second five-member federal posse led by Speed left Guthrie to join in the pursuit.

Speed arrived just in time to get himself killed, but Bitter Creek didn't do the deed. That Friday morning, Roy Daugherty, known in Oklahoma and Indian Territories as Arkansas Tom Jones, was recuperating from a hangover or illness on the cramped second floor of the so-called OK Hotel nearby when he heard the commotion downstairs. From his second-floor window, Daugherty killed Speed and the young Simmons boy (possibly by mistake) and may have also killed the two other deputy U.S. marshals and a traveling salesman, who died later that day.

This wasn't even the first significant large-scale gunfight in the place we now call Oklahoma. On April 15, 1872, at Flint, near the Arkansas border, nine years and five months before the Tombstone, Arizona Territory "Gunfight at the OK Corral" in which the Earp brothers and Doc Holliday shot down three men who were resisting arrest, Ezekiel "Zeke" Proctor was being tried in a Cherokee court for the murder of one Polly Beck, whom Proctor had killed during an argument with her husband, perhaps accidentally. Polly's family didn't trust the tribal court and asked the federal court at Fort Smith, Arkansas, to intervene. As many as eleven people were killed that day in the "Going Snake Massacre," a gunfight between Cherokee tribal members and federal marshals. And

it happened during a murder trial. The judge, one juror and several spectators were wounded.

Doolin was born in Johnson County, Arkansas, three years before the American Civil War but left home at about age twenty-three in 1881. Not much is known for sure about his early life in the Oklahoma and Indian Territories, other than that he worked as a ranch hand before getting into trouble for the first time in Coffeyville, Kansas, during July 4 festivities in 1891. He briefly exchanged gunfire with local law enforcement officers after trying to buy some beer.

Some sources claim that prior to that incident, Doolin met Emmett Dalton of the notorious Dalton gang while working on a ranch near present-day Pawnee, Oklahoma. In his late life memoirs, Emmett claimed that Doolin was among five men who had joined the Dalton gang two months earlier for a May 15 Santa Fe train robbery near Wharton (present-day Perry), Oklahoma Territory.

And Doolin may have participated in other Dalton gang train robberies, among them the mid-September 1891 job at Leliaetta near Wagoner, Indian Territory, and a June 1, 1892 robbery at Red Rock near Marland in present-day Noble County, which yielded $75,000, some $1.9 million in modern money. Perhaps Doolin also participated in the last Dalton gang train robbery at Adair, Indian Territory, on July 14, 1892, in which a doctor was killed.

Hard Times in the Robbery Business

Following the Adair job, the Dalton boys downsized their gang, discharging Doolin and several others. But in doing so, they had done Doolin and the other displaced robbery workers a big favor. For on October 5, 1892, during a raid on Coffeyville, Kansas, every remaining member of the Dalton gang except Emmett was killed. There is no real evidence that Doolin was anywhere near the Coffeyville debacle.

Most historians consider the $1,500 robbery of a DM&A train at Caney, Kansas, which occurred seven days later, to be the first Doolin gang job, an organization that stole some $165,000 in six years, about $4.6 million in modern money.

George "Bitter Creek" Newcomb, Charlie Pierce, Ole Yantis and perhaps Bill Dalton, a younger brother of the doomed Coffeyville brothers, may

have also joined up by then. Whoever was with him, Doolin and his gang struck again in Kansas on November 1, 1892. This time, they robbed the bank at Spearville, drawing the ire of Ford County sheriff Chalk Beeson, who promptly drove a horse team down to Guthrie, Oklahoma Territory; got himself sworn in as a deputy U.S. marshal; and raised his own posse.

Beeson and the others surrounded a house near Orlando in northwest present-day Logan County, where Ole Yantis was staying with his sister. After Yantis died trying to escape, the posse found a wad of money from the Spearville bank in his pocket.

And with this, the Doolin gang went dead silent again until June 3, 1893, at about 1:20 a.m., when they robbed a Santa Fe train at Cimarron, Kansas. The *Meade County Globe* reported the next day:

> *The train had just pulled out of that town when the engineer saw a danger signal near the bridge and stopped the train, when two of the men jumped onto the engine and with revolver drawn commanded the engineer to go with them to the express car with a sledge hammer to batter in the door. When they arrived the messenger refused to open the door and after firing some shots into the car they blew the door off with dynamite. They had shot the messenger through the side and disabled him. The robbers took the contents of the way safe and commanded Whittlesey to open the through safe but he could not do so. It is thought they secured about $1,000 in silver, and mounting their horses rode off to the south.*

The *Globe* also reported that the next morning, the county sheriff in Meade, Kansas, received a telegram from Cimarron informing him of the robbery and instructing him to be on the lookout just as the Doolins rode their horses east of Meade. In fact, a local judge saw them as they passed the corner at his place going south. Soon after, the sheriff and a deputy gave pursuit but couldn't find them. The Doolin crew dined that evening at a ranch ten miles southeast of Meade. The next day, a Kansas rancher named John Randolph entertained the Doolin gang at breakfast, as the *Meade County Globe* reported on June 22:

> *They stopped at his place about 11 o'clock on that morning and wanted their dinner. Said they had been after a horse thief. They said they were in a hurry and to get them a bite quick. They unsaddled their horses and fed them, leaving their Winchesters on their saddles. Going into the house they sat down a few minutes to wait for the preparation of the meal and in that*

many minutes were all sound asleep in their chairs. When dinner was ready John awoke them, little thinking he had in his house four men who were desperate robbers and for whose capture there was a reward of $10,000. It is safe to say that had honest John known this he would have bagged them and by this time had a snug little fortune down in his jeans—but he did not know it—so there's the rub. But at any rate he got a good squint at them, and will know them if he ever sees them again.

Randolph told the *Globe* that the gang "seemed just as quiet and serene as though they had been common farmers who had dropped in to pass the time a day. John says they were all gentlemanly in their actions and seemed well bred." A little over two months later, the Doolin gang proved otherwise at Ingalls.

Doolin had met his wife, Edith, the daughter of a local minister named Ellsworth, in Ingalls. And only three months after the early September 1893 Ingalls gunfight, newspapers reported that he was camping nearby. Some say that he celebrated the New Year by robbing a Payne County postmaster, but more certainly, on January 23, 1894, Doolin and several others robbed the Farmer's and Citizen's Bank in Pawnee.

That very day, U.S. marshal E.D. Nix, just returned from Washington, publicly denied recent newspaper articles claiming that he was trying to arrange for Doolin and his gang to surrender in exchange for two-year sentences.

Almost five months later, on May 10, 1894, Doolin led his only raid into Missouri, mortally wounding former state auditor J.C. Seaborn after robbing a bank at Southwest City near the Indian Territory border.

That killing drew the immediate attention of E.D. Nix, the federal U.S. marshal for Oklahoma Territory, who dispatched deputies Heck Thomas, Chris Madsen and Bill Tilghman, known then as "the Three Guardsmen" to find the Doolin crew.

Meanwhile, Frank Dale, chief justice of the Oklahoma Territory, wrote to the United States attorney general on June 16, 1894, that he had seen Bill Doolin several times in the past two or three weeks. Dale told the attorney general that Doolin was "anxious to drop the business he is in and will willingly come in and give up, provided he can have fair treatment and not too long a term in the Pen." Two days later, Bill Dalton was killed near Ardmore, Indian Territory. And nothing came of the Doolin gang surrender initiative.

As it turned out, the Doolin gang robbery of a Rock Island train at Dover, Oklahoma Territory, in the southern reaches of present-day Kingfisher County in early April 1895, was their last hurrah. By now, Doolin was

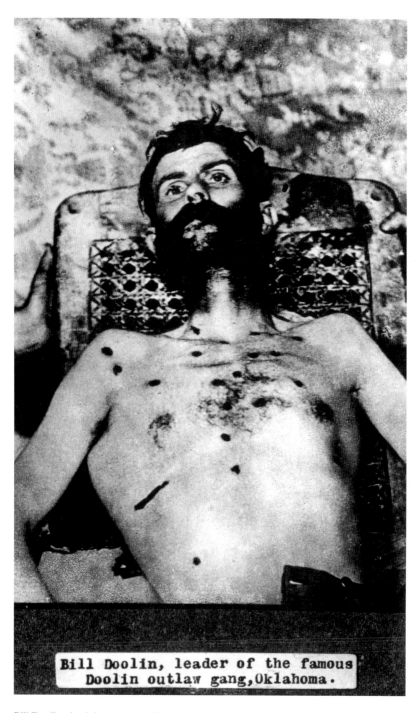

Bill Doolin, leader of the famous Doolin outlaw gang, Oklahoma.

Bill Doolin, death by shotgun. *Western History Collections, University of Oklahoma Libraries.*

suffering from consumption, rheumatism aggravated by several gunshot wounds or both.

Deputy U.S. marshal Tilghman stepped off a train in Guthrie shortly after noon on January 16, 1896, with Bill Doolin himself, neither shackled nor handcuffed. Oklahoma Territory newspapers told competing stories of the capture. In the most frequently told version of events, Tilghman trailed Doolin to the Davy Hotel in Eureka Springs, Arkansas, where the fugitive was taking mineral waters for his ailments. Although many accept this version, skeptics at the time and even today have observed that the train Tilghman and Doolin stepped off in Guthrie arrived from the north, not the east.

Whatever the circumstances of the arrest, Doolin spent the next seven months in the Guthrie jail, except for a day trip to Stillwater in which he was arraigned for his part in the Ingalls gunfight. Dynamite Dick Clifton joined him in Guthrie on June 22, but not for long. On July 5, Doolin and Clifton joined twelve other inmates in a successful jailbreak.

By most accounts, Doolin fled directly to Lawson (not Lawton), a hamlet in the southern environs of present-day Pawnee County and six miles west of Jennings, to visit his wife, Edith, who was staying there with her parents. Two months after his escape, on January 24, 1896, Doolin was killed there shortly after dusk by someone in the ten-man posse led by deputy U.S. marshal Heck Thomas.

Doolin was quietly leading his horse away from the Ellsworth house in the coming darkness, with his rifle in his other hand, when Thomas ordered him to surrender. Doolin began shooting toward Thomas instead, but he didn't last long. At least sixteen bullets found their mark, leaving the outlaw Bill Doolin's emaciated corpse staring into the distant nothingness.

And with that, all the principal members of the Doolin gang were dead except "Little" Bill Raidler, a part-timer who did his time in federal prison. While there, he was a friend of William Sydney Porter, who became the famed writer O. Henry. Raidler died a somewhat respectable citizen of Yale, Oklahoma, in about 1905. He lived about ten miles from Ingalls. Lucky for him that he'd joined the Doolin gang too late to be one of the combatants there.

4

HENRY STARR

FROM HORSEBACK TO CADILLAC

He was a dapper, well-dressed gentleman who lived in Tulsa not far from the mayor and only a block or two from where the county sheriff lived. Henry claimed to know them both, and he might have; after all, Tulsa had welcomed outlaws from its earliest days as a cow town, so long as they robbed banks, stages and trains elsewhere.

Henry Starr didn't do the first automobile-powered robbery in American history, but he knew and admired the men who did. Oklahoma's Poe-Hart gang invented the technique and used it for the first time on October 18, 1916, robbing the Isham Hardware store, where Coffeyville, Kansas residents had armed themselves to destroy the ill-fated Dalton gang twenty-four years before. But Henry arguably committed more bank robberies than anyone in the United States before his death at the beginning of the Roaring Twenties while trying to rob an Arkansas bank and get out of town in a car.

He had deep roots in Oklahoma, descending from James Starr, a Cherokee stalwart of the Treaty Party, which had advocated the peaceful removal of the party to Indian Territory in the 1830s. James was targeted for assassination after the Trail of Tears as a consequence. Although James survived the first efforts, his son Thomas Starr struck back against an innocent trader and his family near Dwight Mission in 1843. And after James Starr was at last assassinated, Thomas was instrumental in the killing of some thirty men whom he considered responsible before a tribal truce was called in 1846.

Henry's own father, George, was a peaceful, honest man. That could not be said for their relation Sam Starr, whose father, Old Tom Starr, hosted the

James-Younger gang and named his place on the Canadian River for Cole Younger. Sam married Belle Shirley, who described herself as the friend of any bold and courageous outlaw. Henry Starr always reminded people who asked him about Belle Starr that she was no blood relative of his.

He was born near Fort Gibson in 1873 and probably left home at age seventeen in 1890. Four years earlier, his father had died. Worse still, his mother promptly married one C.N. Walker, with whom he quarreled before leaving to work on a ranch near Nowata, Indian Territory, a few miles away. Henry had initiative, the kind that led him to supplement his cowboy income by bootlegging, then and there known as "introducing spirits into the [Indian] Territory."

The judge in Fort Smith didn't believe Henry's claim that he'd borrowed the wagon and didn't notice the booze. And he was less impressed several months later when young Henry was charged with horse theft. Now, "the Bearcat," as Henry Starr came to be known, jumped bail and went on the dodge.

His first heist was not far from where he worked. Starr and persons unknown, suspected to be Ed Newcome and Jesse Jackson, robbed the Nowata Depot of some $1,700 in July 1892. The month after the Daltons met their Waterloo, Starr and Milo Creekmore robbed the Shufeldt Store at Lenapah, a burg south of Coffeyville, moving on to rob a store in Sequoyah later that November. These last two mercantile transactions netted Starr and Creekmore about $480, bringing Starr and his three partners to a grand total of some $57,000 today.

That was more than enough to attract the bloodhounds.

MURDER AT WOLF CREEK

Floyd A. Wilson had served as a sworn deputy U.S. marshal with legendary black lawman Bass Reeves nine years before, but he was with the Fort Smith, Arkansas police department that November when his old friend Henry C. Dickey approached him about serving on a posse. Dickey was a deputy U.S. marshal and Pacific Express Company detective at a time when that kind of dual employment was perfectly legal.

The next month, after Wilson was reappointed as a deputy, the pair set out for the Cherokee Nation, arriving at the Arthur M. Dodge "XU" Ranch some seven miles north of Nowata on Monday, December 12. They searched the immediate area for the fugitive, returned to the XU for dinner the next

day, went into the ranch house and learned that Dodge had just spotted Henry riding toward nearby Wolf Creek. Wilson's horse was saddled, but since Dickey's was not, Wilson rode ahead after Dickey instructed him to arrest Starr if possible.

But by the time Dickey caught up with them, the shooting had commenced.

"Hold up, I have a warrant for you!" Wilson yelled at Starr, who had already reached the stream that might have protected him if he'd been a little faster. Instead, the fugitive dismounted, faced Wilson and yelled back just as the deputy rode toward him and jumped off the horse, firing over Starr's head, intentionally or otherwise. Starr had a better day. He shot Wilson five times, placing the last one in the deputy's chest, point blank.

That was about the time Dickey caught up, just in time to fire a few rounds without effect before Starr mounted the dead deputy's horse and rode away toward the Osage Nation. Later, he recalled that he fled with "fear tugging at [his] heart and [his] brain afire."

In the Osage, he hid out with Jackson and one Ed Newcomb near the Big Caney River, but they blundered into a combined force of some fifteen deputy U.S. marshals and Indian police on January 20, 1893, near Bartlesville. Still, they somehow managed to escape. Later that month, they rode seventy-six miles to Chouteau, where they robbed the railroad depot and a store and followed that with a raid on Inola nearby in early February. It was time for Starr's first bank robbery.

Caney National Bank in the little Kansas town just north of the Indian Territory seemed like a prospect. Frank Cheney, a farmer who lived just north of Wagoner, followed Starr into the bank and walked directly into the vault. He helped himself to some $5,000 in coin and currency while Starr hustled the employees and customers into a back room.

Their next stop was Pryor Creek, Indian Territory, on May 2 for an evening robbery of the MK&T train. When they couldn't get access to the safe, they robbed the more affluent-looking passengers of their cash. Later, Starr claimed that they relieved the passengers of $6,000 in cash, as well as a "consignment of unset diamonds."

Their next target was the People's Bank in Bentonville, Arkansas. The day before the job, Starr had scouted the prosperous little town, but on June 5, the five-man robbery team ran into some serious trouble.

"They're holding up the bank!" a youngster shouted into the courthouse. After the alarm was sounded, gang member "Happy Jack" Cumplin dodged rifle fire from three or four men across the street as, inside the bank, Starr loaded up on silver, gold, currency and hostages. Later, as the gang and their

captives left the bank, one brave woman reached out and pulled a hostage carrying the silver into a building. Despite the setback, the Starr crew still escaped with $11,000 and rode on to Cheney's farm near Wagoner, Indian Territory, where they divided the money, made plans to reunite later and split up.

Kid Wilson, Henry Starr and Starr's wife soon boarded a train at Emporia, Kansas, with plans to visit California, but during a layover in Colorado Springs, Colorado, Wilson and Starr were arrested and returned to Fort Smith.

Starr faced thirteen counts of highway robbery and a murder charge for killing Floyd Wilson in the court of Judge Isaac Parker. A jury found Starr guilty of all charges, but the murder conviction was reversed twice by the U.S. Supreme Court before Starr finally pleaded guilty to manslaughter and was sentenced, on January 15, 1998, to serve a combined sentence of fifteen years and seven days. He left for the federal prison at Columbus, Ohio, eight days later, with that old Bentonville bank job hanging over his head but an ace in his sleeve.

Only five years later, President Theodore Roosevelt reduced his fifteen-year sentence to time served and released him out of admiration for something Henry Starr had done in the Fort Smith lockup on the evening of July 26, 1895. Back then, Henry had convinced cold-blooded Crawford Goldsby, better known as "Cherokee Bill," to hand over a pistol and surrender after killing guard Lawrence Keating during an escape attempt. Although Goldsby didn't have much to lose that hot July evening, Starr had observed how gentle Bill was with his mother during a few visits. "Your mother wouldn't want you to kill any more than you've already killed," Starr told him. "Don't make it any harder for her." Goldsby surrendered and was hanged the next year.

And now, in 1903, when President Roosevelt released him, Henry moved to Tulsa, where his mother ran a restaurant. As the next five years went by, he got married, became a father and even took his young family to watch the inauguration of Oklahoma's first governor in 1907. But there was trouble brewing in Bentonville.

The Arkansas authorities hadn't forgotten about that 1893 Bentonville robbery. And Oklahoma governor C.N. Haskell had turned down extradition requests on technical grounds, but Starr didn't know that. During the winter of 1907–08, he had teamed up with Kid Wilson in the Osage. They bought some rifles and headed north on Friday, March 13, 1908, to Tyro, Kansas, where they robbed the bank. Years later, Starr regretted that he'd gone wrong again because he "preferred a quiet and unostentatious interment in a respectable

cemetery rather than a life on the Arkansas convict farm."

From there, they moved west; robbed the bank in tiny Amity, Colorado, near the Kansas border of about $1,100; and dissolved the partnership. Kid Wilson was never heard from again, but Henry Starr eventually made his way to Bosque, Arizona, southwest of Phoenix. One year after the Amity bank job, he was arrested there, returned to Colorado, promptly convicted and sent to the state prison, where he wrote *Thrilling Events: Life of Henry Starr*. He was released on the condition that he would never leave Colorado and started his own restaurant near Amity, but within a year, he left the state with a merchant's wife.

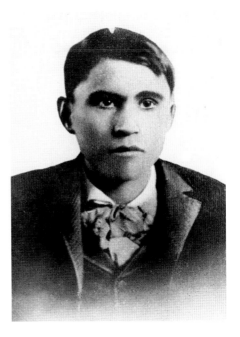

Career bank robber Henry Starr. *Western History Collections, University of Oklahoma Libraries.*

Perhaps it was only a coincidence that shortly after Henry Starr left Colorado, fourteen Oklahoma banks were robbed at two-week intervals beginning in September 1914 and ending the following January. Most of these daylight robberies were in the eastern counties, but five were in central Oklahoma. The money taken totaled over $31,000, about $722,000 today. A $15,000 reward ($1,000 for any single robbery) was appropriated by the legislature just before the cashier at the Carney State Bank, four days after Christmas, identified Henry Starr as the leader of the men who robbed him. A couple who fed the gang later that day also identified him.

The new Oklahoma governor, Robert L. Williams, promptly offered $1,000 for Starr dead or alive, but the Bearcat had made other plans, as he and the woman he'd brought back from near Amity, Colorado, lounged about his Tulsa home, not far from where the mayor lived and only a block or two from the county sheriff.

Much like Coffeyville, Kansas, Stroud, Oklahoma, had two banks. Henry Starr believed that he had a large enough crew to accommodate them both—on the same day—without being wiped out the way the Daltons were twenty-three years earlier. Starr masterminded the only successful two-for-

one bank robbery in American history but ended up in the hoosegow while his accomplices enjoyed the loot.

The six-man Starr gang rode into Stroud on March 27, 1915, but immediately ran into trouble, even as a combined $5,800 in cash was being collected at the Stroud National and the competing First National Banks. During the gun battle that followed, Henry Starr and Lewis Estes were so badly wounded that they had to watch the rest of the gang escape. Later, Starr complimented Paul Curry, the seventeen-year-old who shot him, on his marksmanship.

The Oklahoma authorities weren't as forgiving, but at least Starr owned up to his errors while serving the twenty-five-year sentence he received five months after being captured. After publicly repenting for his life of crime, he was pardoned a few months shy of his fifth year at the Oklahoma prison in McAlester.

He returned to Tulsa, married a third time, moved to nearby Claremore and was successful in the movie business for a time. We will never know whether he was broke or just bored, but on February 21, 1921, he drove into Harrison, Arkansas, with three companions and stopped in front of the People's State Bank. The other bank robbers drove away without the $6,000 he had stuffed into his pocket because Henry couldn't join them. While Starr was watching a cashier open a safe, the former bank president, age sixty, pulled out a rifle he'd long kept in the bank vault for a day like this and shot him in the right side. Starr hit the floor paralyzed and died two days later, after telling his attending doctors, "I've robbed more banks than any man in America."

And quite possibly, he had.

5
TERMINALLY DUMB

Most criminals are not mental giants; that's why they're criminals. Professor Moriarty of Sherlock Holmes fame was a wizard of fictional crime, but in the real world you are more likely to find clowns like these.

Even the experienced criminal is not immune to stupid. Take the fugitive Billy the Kid, who saw a shadowy figure in a small room and asked, "*Quien es?*"("Who is it?"), then absorbed Pat Garrett's bullet by way of reply. Or the nitwits who pulled the Roy's Branch train holdup near St. Joseph, Missouri, back in 1893. The three original members of the gang even recruited three more men for the job. Their mistake was taking the new guys at face value; one was a cop, and the other two were citizens working with the police.

When the three real outlaws pushed into the express car, they were surprised to find it inconveniently full of policemen, who promptly blew two of them away. The third gang member was wounded but got clear—until the next day. He asserted his innocence but convinced nobody. Not only were there three honest men to identify him for what he was, but he also had a bloody mess where three fingers used to be and a pocket full of cartridges to boot.

The *dummkopf* syndrome extended to both the famous and obscure alike. Sooner or later, they all did something stupid, which got them a ticket to a prison cell or the graveyard. Their ailment was about equal parts stupidity and arrogance.

Among the once famous oafs was George Birdwell, an experienced hoodlum, robber and killer. He was right arm to Charles Arthur Floyd, known to his friends as "Choc" and to the rest of the public as "Pretty Boy."

George should have known better than to take on the little bank in Boley, Oklahoma; in fact, Floyd warned him against it.

But Birdwell thought he knew better. So, with a couple other professional thugs, he drove into Boley one day late in 1932. Boley was a thriving all-black town, one of a number in Oklahoma; its citizens had taken careful precautions against bank robbery, the favorite crime of those days, for banks had been robbed within a few miles of Boley. The town stockpiled weapons, and the bank installed an alarm linked to other businesses.

The citizens of Boley were tough and prepared, but Birdwell helped them a lot. First, he chose a Saturday for his raid. Predictably, the town was full of farmers shopping, and the prairie chicken season had just opened, so many of the shoppers were buying shotgun ammunition as well as groceries.

Second, he left their getaway car parked facing away from their escape route, requiring the driver to back up and then make a U-turn to reach the highway and safety—all this when speed was of the essence. Also, since the car was parked with the driver's side toward the bank, there was only one door to jump into when the time came to escape. There would have been two, had the car been parked facing the escape route, with the two passenger's side doors toward the bank.

In the event, Birdwell was killed dead and so was the getaway car driver as he tried to manage his U-turn. The third thug was filled full of birdshot—as many as two hundred of them—and went off to prison.

Then there was Grat Dalton at Coffeyville, first piling up a sack full of a bank's silver, a heap so heavy it was impossible for one man to move. Grat then stood around waiting for the vault to open, deceived by a young teller's unctuous lie that the bank's vault was locked. It wasn't, of course, it being the middle of the business day.

But while Grat stood waiting for his cornucopia to open, the town's two hardware stores were passing out weapons to the alerted citizenry right outside the door. One of the local folks shot Grat dead. *Sic semper* stupid.

Then there was Elmer McCurdy, who had all the brains of a doorknob. With some confederates, he pulled a two-bit robbery and then separated from the other hoodlums. Carrying his puny share of the loot, which included a couple demijohns of whiskey, he fled—on foot, his first stupid mistake. Perhaps to console himself about the lousy haul, he sampled the whiskey liberally as he walked until he was thoroughly spifflicated—error number two. Later, instead of going past a farm to put distance between himself and the posse, poor Elmer sought and received permission to spend the night in the barn—his third very bad idea.

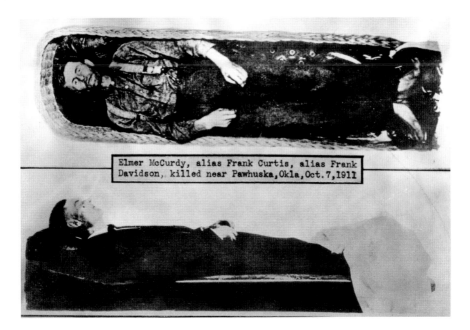

Elmer McCurdy, alias Frank Curtis, alias Frank Davidson, killed near Pawhuska, Okla, Oct. 7, 1911

Elmer McCurdy. *Western History Collections, University of Oklahoma Libraries.*

When he awoke, Elmer was surrounded by the law. Summoned to surrender, he made error number four. He fought and, in the ensuing gunfight, came in a bad second.

In fairness, Elmer now began a far more successful second career. He became an exhibit first in the mortician's emporium and then in a series of freak shows. Step right up, folks, only a quarter to see a real, dead outlaw. Finally, substantially the worse for wear by the ravages of the years, multiple coats of wax and luminous paint, he ended up as what he began: a dummy, or so it was thought when he was "discovered" in 1977 in a wax museum display in California during the filming of an episode of *The Six Million Dollar Man* television series. Soon thereafter, he was buried next to the infamous Oklahoma outlaw Bill Doolin.

Elmer's extended second career was unusual, but he shares with other outlaws the common trait of paralysis of the brain. Cerebral density got him killed.

Alphonso Jennings was just as stupid, but he came from a good family, was the son of a judge, went to law school and became a lawyer himself, like several of his brothers. All went well until the day two of his brothers, Ed and John, got crossways with another lawyer in court. The other lawyer told one of the brothers he was grossly ignorant of the law—which he well may have

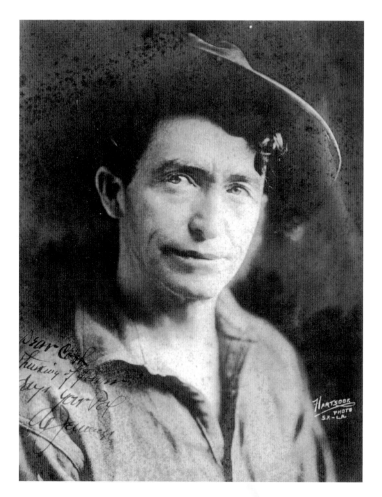

Al Jennings—big smoke, no fire. *Western History Collections, University of Oklahoma Libraries.*

been—and was called a liar in response. Tempers flared. The other lawyer was Temple Houston, son of Sam Houston of Texas. Temple was just as good with a gun as he was with a writ. Before meeting the Jennings boys in Woodward, Oklahoma Territory, he even bested Billy the Kid in a target shooting contest, or so it is said. The judge quelled the courtroom squabble in Woodward, but bitter feelings remained. And at the end of the day, the brothers found themselves in the Cabinet Saloon with Houston and a friend. The earlier courtroom quarrel led to a shootout in which the Jennings brothers came in a bad second. Ed was dead, such brains as he had running out a hole in his head. Al's brother John was wounded and ran for his life.

A jury decided the killing was in self-defense, there being solid evidence to that effect and some circumstantial evidence that the shot that killed Ed Jennings was the result of lousy marksmanship by his fleet-footed brother John. Al fulminated about the "perfidy" of the prosecution, loudly announcing that his brother had been shot by "sneaking and unseen" men in what amounted to an ambush.

This gave Al his big chance. Threatening bloody vengeance on his brother's killer, he found it convenient to turn outlaw at the same time. Oddly, though Houston was well known and easy to find, Al never seemed to be quite able to arrange to be at the same place Houston was. Instead, he went off a-robbing and found it most unprofitable, mostly because he was inept to a degree far exceeding the average, even among outlaws. A prolific and knowledgeable western writer dubbed him the "Clown Prince of Oklahoma Train Robbers." The title fits Al precisely.

He started his dubious career in crime in 1896, forming a gang with still another brother named Frank, a couple of nonentities called the O'Malley brothers and Little Dick West, a real outlaw. They frequented the almost lawless country along the South Canadian River, robbing little stores and saloons and attempting the occasional train.

They had a few successes, like the post office they hit for some $700, but most of their crimes were busts, like the train they tried to stop by stacking ties on the tracks and setting fire to them. The engineer charged the obstacle, filling the air with flaming ties, and pushed on through.

That was less embarrassing than getting a train stopped and blasting its safe, only to discover that two successive charges of dynamite couldn't dent it. They had a repeat performance with another train safe, also tougher than both them and their dynamite. During one of these abortive attempts, clever Al successfully knocked off his own mask.

Al's big strike, the bonanza all criminals dream of, also fell flat. The train was supposed to be carrying almost $100,000, but again Al found a safe impervious to dynamite. Robbing the passengers yielded the robbers only four or five dollars each. That tore it for Little Dick West. He'd had enough of running with idiots and would operate elsewhere until he perished at the hands of a posse in 1898.

The gang, all wounded, soon fell before a posse. Al got five years, only to emerge, get himself readmitted to the bar and run first for county attorney in Oklahoma City and then for state governor. Fortunately, he was unsuccessful. Still full of noisy bravado, he tried his hand at Hollywood, where he dabbled in films, posed for photos with all sorts of cowboy actors and celebrities and otherwise made an ass of himself.

He won a measure of fame with a book called *Beating Back* and then produced a movie of the same name. The film was a wild congeries of half truths and downright inventions. Emmett Dalton saw the thing and commented, "I had one hell of a good laugh."

Still, Al was content. After all, he was a legend in his own mind.

That brings us to the other Oklahoma outlaw bearing the same first name. Al Spencer was born into a respectable family but didn't share their morality. He did three prison stretches for cattle rustling, burglary and sticking up a local postmaster as that gentleman walked home from a poker game.

Al didn't learn a thing. After escaping from prison, he went right back to crime, this time working with other bad hats robbing small banks in Oklahoma, Kansas and Arkansas. Their biggest payday was a Kansas jewelry store, where they looted some $20,000 ($274,000 today) in watches and jewelry. That had its own hazards, of course, because for loot like that you have to find a reliable fence, which took a huge cut of your profit.

Along the way, Al further demonstrated his intellectual poverty by driving around with a jug of nitroglycerine on the running board of the car, covered with a blanket. Discovering that for some reason the blanket had caught fire, he disposed of the nitro, miraculously without an explosion.

Al became the Typhoid Mary of his own gang. The members one by one became prisoners of the law, either dead or wounded. Three of them, including Al, escaped one ambush only by abandoning their car and fleeing on horses they had stashed. Between jobs, they sought refuge in the wild country of Oklahoma's Osage Hills but didn't have the sense to stay there. During their sabbatical, they held up the post office in Pawhuska and tried to dynamite the safe. A mighty explosion produced absolutely no effect on the safe except totally jamming its door. No money—again.

And they had killed two men, one of them for nothing at all. "You ignorant bastard! You've killed two innocent men, and now there'll be hell to pay," said one of their female "companions."

There was. Most of the gang ended up in the hands of the law, some of them shot, one so badly that he lost a leg to amputation. Unperturbed and reinforced with new recruits, Al took on another train, said to be carrying some $20,000 in Liberty Bonds. They also got some of the passengers' cash and a paltry amount from the express car safe.

Al supposedly claimed he could protect himself from fingerprint identification by wearing rubber fingerstalls (protective coverings used for injured fingers) while he "worked," if that's the word. The idea is also credited to one of his gang, an oaf named Ike Ogg. Whoever thought it up,

the law sensibly asked around to see who had been buying lots of fingerstalls. Ogg eventually rolled over on his confederates.

No matter how lucky you are, you can do only so many stupid things without getting caught. The end for fumbling Al Spencer came on a September night on a bridge along the Oklahoma-Kansas border. A posse waited in ambush as Al committed his final stupidity. Summoned to surrender, he fired into the darkness and, in return, was punctured eight times, going from terminal dumb to terminal dead. Nobody missed him much. The survivors of his gang were either sent to prison or killed by the law, save for one who beat his wife so often that she finally filled him full of holes.

Finally, consider Dave Rudabaugh, who rejoiced in the sobriquet "Dirty Dave," a reference to his permanent and penetrating stench. His personality was just as rank. He robbed people, killed people, rolled over on his companions to save himself and, at various times, ran with some of

the worst outlaws, including the Cowboy faction of Tombstone fame and the Las Vegas, New Mexico cabal of Hoodoo Brown.

Dave ultimately took his foul smell and vicious ways down to Mexico when the United States became just too hot for him. He inflicted himself on a fair town called Parral, down in Chihuahua. Disappointed in a card game in the local cantina, he killed a couple of the locals—not a smart idea for a smelly gringo stranger.

The cantina lounge-abouts vamoosed at a high lope. Dave soon departed himself, since there was nobody left—alive—to play cards with. Trouble was, he couldn't find his horse. And then Dirty Dave showed just

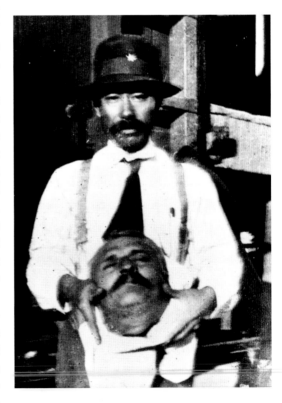

A rurale holding the remains of "Dirty Dave" Rudabaugh. *Western History Collections, University of Oklahoma Libraries.*

how bright he was: he went back inside the cantina only to find much of the town waiting for him.

Dave had worn out his welcome in Parral; the locals not only ushered him into the next world but also removed his head, droopy mustache and all. They left his hat on top and paraded the head around town impaled on a pole, making a sort of fiesta.

It was about the only time Dirty Dave brought other people pleasure.

6
DEACON JIM MILLER
THE WORST MAN I EVER KNEW

Oh God!" cried Gus Bobbitt as the shotgun roared out of the twilight gloom. "Oh God!" The cattleman toppled from his wagon, and his panicked team ran.

Bobbitt's neighbor Bob Ferguson jumped from his own rig, but there was no more shooting, only the clatter of hooves as a horse broke out of the thicket from which the fire had come. Ferguson recognized him as the same man who had just passed Bobbitt and Ferguson moments before. Behind his saddle had been something wrapped in what looked like a folded slicker.

Inside the slicker was a shotgun, the favorite weapon of James P. Miller, commonly known as "Deacon Jim," from his favorite dress of black broadcloth and his pretense of churchgoing respectability. Born in Arkansas in 1866, Deacon Jim was orphaned early and sent to live with his grandparents in Coryell County, Texas. When he was eight, his grandparents were murdered; he was arrested for the crime but was sent to live with his sister and brother-in-law, John Coop. Ten years later, a shotgun killed John Coop as he slept on his front porch one evening.

This time, seventeen-year-old Miller was tried and convicted. Miller's alibi was that for at least part of the evening he had been at a camp meeting, but his witness—a young lady—admitted at trial that he had left her and "did not return until the regular service was over and the shouting commenced." Miller got life, but his conviction was overturned on appeal.

Miller drifted into McCulloch County, where he raced horses and punched cows for Mannen Clements Sr., who had killed at least a couple

men himself. Miller got to know Mannie Clements's equally violent son, Mannen "Mannie" Clements Jr., and Sallie, his pretty daughter.

In 1887, Mannen Clements was killed in a saloon by city marshal Joe Townsend. Shortly afterward, Townsend, riding home at night, was knocked out of his saddle by a shotgun blast and lost an arm. The ambusher was never identified, but Miller, widely suspected, left the country at a high lope.

He drifted on through the Mexican border area and would later brag that he had "lost my notch stick on Mexicans that I killed out on the border."

In 1891, he rode into Pecos, Texas, a raw, tough town just beginning to acquire a little civilization. Its population now spent its time "making a living, going to church, picnics, engaging in a friendly drink now and then, praying three times a day and fist-fighting twice a week."

Miller hired on as a deputy to Sheriff Bud Fraser, who did not question his antecedents. In West Texas around the turn of the century, speculating about a man's back trail was just not done; what mattered was how he behaved today and maybe tomorrow. You did not ask about yesterday.

For a while, Miller's conduct was all any sheriff could wish. He neither smoked nor drank and was a regular at church. He became a familiar figure in Pecos, always making his rounds in a black broadcloth coat, black boots and black Stetson. The nickname "Deacon Jim" was a natural.

In 1891, Miller married Sallie Clements. As stock theft increased in the Pecos Valley, Miller spent much time alone in devoted pursuit of rustlers. Trouble was, he didn't seem to catch anybody. Sheriff Frazer's brother-in-law, Barney Riggs, suggested a logical first step: fire Miller, whom he rightly suspected of rustling.

Miller laughed off the accusation, church members supported him and the town took sides. Maybe Miller didn't respond with gunfire because his deputy's star was such wonderful cover for his rustling business. Maybe he was reluctant to challenge Riggs, a tough hombre himself. Sentenced to life after he killed a rival for a woman's favors, Riggs was pardoned in 1887, after he had killed two convicts who attacked the warden.

Sheriff Frazer, without proof of Miller's dishonesty, kept him until he killed an "escaping" Mexican prisoner. Riggs alleged Miller had murdered the man because he knew where Deacon Jim had hidden a pair of stolen mules. Sure enough, on instructions supplied by Riggs, Frazer found the mules and immediately fired Miller.

In the summer of 1892, Miller opposed Frazer for sheriff and was defeated. Miller managed to win the office of city marshal, however, and began to surround himself with gunmen, including Mannie Clements

and one of the Hardin clan. Animosity festered and came to a head in May 1893, while Bud Frazer was away. The criminal element simply took over Pecos.

Somebody wired Frazer, who caught a train for home. Miller arranged an ambush at the station, but citizen Con Gibson overheard the plan and wired Frazer. When he got off the train flanked by Texas Rangers, the plot fizzled; so, unfortunately, did the case against Miller, Clements and Hardin.

The Pecos ulcer continued to fester. Con Gibson, who had warned Frazer, was murdered in New Mexico by a man apparently working for Miller, but Frazer could do nothing until, finally, he took matters into his own hands on a morning in 1894.

Passing Miller in front of his hotel, Frazer roared, "Jim, you're a thief and a murderer! Here's one for Con Gibson!"

And he drilled a bullet into the front of Miller's customary black coat and a second into the gunman's right arm. Miller drew left handed and returned fire, but his slugs went wild. Frazer put three rounds into a space the size of a coffee cup, right over Deacon Jim's heart. He should have been dead.

But he wasn't, and now people learned why he wore the black broadcloth coat in all weather. Underneath it was a steel plate, which had deflected Frazer's bullets. Miller was badly bruised but very much alive and panting for revenge. "I'm going to kill Bud Frazer," he promised, "if I have to crawl twenty miles on my knees to do it." While Miller nursed his grudge, some leading citizens, pillars of the church, supported Miller because of his sanctimonious Sunday behavior and his recent "conversion" at a revival meeting. Frazer lost the next election.

Stung, he left Pecos for new prospects in New Mexico. But the feud wasn't over yet. Frazer returned to Pecos briefly to settle some personal affairs and met Miller on the street. This time, Frazer was carrying a Winchester and Miller his favorite weapon, a shotgun. Knowing Killin' Jim had been looking for him, Frazer opened up, nailing Miller in the right arm and left leg, then twice over the heart. Still, Miller stayed on his feet, and Frazer took to his heels.

Frazer was arrested, but trial was transferred to El Paso and ended in a hung jury. The second trial was put over for a year. To complete Miller's unhappiness, Frazer was acquitted and returned to his new place in New Mexico. Both he and Miller knew their fight was not over.

In September, Frazer visited family in Toyah, about eighteen miles from Pecos. Frazer sat playing seven-up at a saloon table on the morning of September 13. Miller, alerted by a confederate, slid his shotgun through the

saloon door and squeezed off both barrels. The buckshot tore Frazer's head off in a shower of blood and bone, leaving his body still seated at the table.

Miller rode back to Pecos, where he was promptly jailed for murder. Before he went, he grandly ordered all of Frazer's supporters to leave the county. Tough Barney Riggs, at least, stayed around town and tangled with two Miller henchmen in the Orient Saloon; one of them was Earhart, the man who had been Miller's lookout in Toyah.

Earhart got off the first shot, but Riggs's return fire drilled his man between the eyes. Riggs then chased the other hired gun into the street and blew the back of his head off. Scooping up a few of the brains, he promised to send them to Con Miller's widow. Tried for murder in El Paso, Riggs was promptly acquitted.

Miller himself was tried for the Frazer murder in Eastland, Texas. After the first jury hung eleven to one, Miller spent the next months helping his minister hold prayer meetings. Little wonder, then, that a second jury acquitted him in January 1899.

Deacon Jim next ran a saloon while working as a part-time deputy in Memphis, Texas. By now, he openly boasted of his murders, even "predicting" them. He urged a man named Earp (no known relation to Wyatt) to swear away an innocent man's life for a $10,000 reward, but Earp turned state's evidence. That should have been the end of Miller's career, but his conviction was reversed, and as he rode the train back to Memphis, he boasted, "Joe Earp turned state's evidence on me, and no man can do that and live. Watch the papers, boys, and you'll see where Joe Earp died."

Three weeks later, Earp was ambushed and shot down.

Miller moved on, ending in 1900 in Fort Worth, where he gambled and speculated in real estate. He and his wife opened a rooming house, and he followed his familiar pattern of joining the church. His real occupation, however—and maybe his hobby—was still killing.

These were the days of the great sheep wars, and Miller hired out to exterminate sheep men at $150 per job. He may have killed as many as a dozen men, some anonymously and others on some excuse such as self-defense. He soon expanded his services to include murdering farmers whose fences obstructed the great cattle herds.

In 1904, he ambushed Lubbock lawyer James Jarrott, who represented several farmers fighting against the big cattle interests. Jim dry-gulched him with a rifle and then shot his helpless victim repeatedly as he lay writhing on the ground. "Hardest damned man to kill I ever tackled," said Miller.

Miller got $500 for murdering Jarrott and began to strut the streets wearing a diamond ring and studs. He branched out into promoting the sale of real estate lots well submerged in the Gulf of Mexico. When in 1905 his salesman threatened to reveal the fraud, Miller shot him down in a Fort Worth hotel. Again, he escaped the law, this time on perjured alibi testimony.

Up in the Chickasaw Nation, lawman Ben Collins had incurred the wrath of the Pruitt brothers by crippling one of them during an arrest. The Pruitts knew who to call. One August evening, a man screamed as the roar of a shotgun split the night near the gate to Collins's little farm. Collins's wife ran from the house, but she was too late. The marshal died hard, getting off four rounds from his pistol after the first load of buckshot knocked him from his horse. But another blast tore into his face, and he was dead by the time his frantic wife got to him.

Investigation identified several conspirators, including the Pruitts, a possible triggerman called Washmood and Miller. Miller had killed the young marshal for $1,800, but he was both smart and lucky. As months dragged on before trial, one conspirator died and one of the Pruitts was killed by a lawman. Late in 1907, out on bail, Miller returned to Fort Worth, in time to answer a call from New Mexico. There was work for him.

The quarry was big game, and the pay was commensurate: $1,500. His target was none other than Pat Garrett, the legendary sheriff who had killed Billy the Kid. Garrett was semiretired now, living up in Dona Ana County, New Mexico, and he had become a major problem to powerful neighbors who coveted his land and his water.

Financially strapped, Garrett leased part of his range to one Brazil, who by prearrangement with Garrett's avaricious neighbors imported the unthinkable: goats. Garrett was appalled and sought any way to rid his range of the voracious beasts before they destroyed it entirely.

In January 1908, Deacon Jim appeared, posing as a cattleman in the market for grazing rights. He made an attractive offer to Garrett, who began to dicker with Brazil to get those accursed goats off his land. Negotiations broke down, however, and Garrett hit Brazil and then told him what kind of a low life ran goats in cattle country.

In February, however, Garrett agreed to go to Las Cruces to talk to Deacon Jim. He traveled with Brazil and a man named Adamson, to whom he had extended hospitality the night before his trip. Garrett carried no sidearm, only a folding shotgun in its case alongside him in a buggy. Garrett, now pushing sixty, had not been an active lawman for years and obviously did not connect cattleman Miller with the deadly Deacon Jim.

And so, along the trail to Las Cruces, when he stopped to answer the call of nature, a bullet tore through the back of his head and another lodged in his stomach. The other two men drove into to Las Cruces. They claimed that Brazil had killed Garrett with his revolver in self-defense, after another argument about goats on the cattle range.

Lucero, the sheriff in Las Cruces, smelled a rat. He found Garrett still lying in the road, his shotgun beside him. But the famous sheriff's fly was still unbuttoned and his right hand still encased in a heavy glove, hardly the garb of an experienced gunfighter ready to attack. Lucero concluded that Garrett's shotgun, loaded only with birdshot, "was placed near the body after he was killed."

The killing emitted an even stronger smell after a Mounted Police officer found horse droppings and two spent Winchester shells near the spot where Garrett was killed. The same officer knew Deacon Jim's record and discovered he was related to Adamson. But Brazil was acquitted, and Miller was never arrested, although there was reason to believe he had no cattle and no need for grazing land. It is only fair to say that a fine biography of Garrett does not accept Miller as the murderer, and there were, indeed, other excellent suspects.

Toward the end of 1908, Killin' Jim's friend and relative Mannie Clements died in a saloon fight in El Paso. Miller was determined to seek revenge. First, however, there was another contract—no unsung nester or humble sheep man, or even a famous sheriff, but a prominent man, a pillar of his community of Ada, Oklahoma. This time the blood price was $2,000, the richest prize of Deacon Jim's ugly career. Vengeance would have to wait.

Ada was a bustling young town, the center of a thriving cotton trade, a city on the way up. It was also a tough place, in or near which thirty-six people had been murdered in 1908 alone. It was also home to a bitter quarrel between unscrupulous saloon operators named West and Allen and hard-nosed businessman and sometime lawman Angus Bobbitt. There had been much disorder as a result, and several killings, but the smoke had cleared, and Bobbitt's rivals left the area to run cattle in Texas.

But they had not forgotten Bobbitt at all.

Instead, they hired Jim Miller. And so it was that Angus Bobbitt drove his wagon back from town one winter night, and a terrible scattergun tore the life out of him at the gate to his own field. Bobbitt lived about an hour, lying with his head in his wife's lap. Tough and clear-headed to the end, he told her how to dispose of his property—and included $1,000 as a reward for the man who killed him.

The Ada citizenry was furious, and a posse immediately set off to run down Bobbitt's killer. This time, maybe arrogant from long immunity, Miller had not covered his trail well. The posse found his horse at the home of a confederate, one John Williamson. Beaten and cowed by a crowd of angry men, Williamson spilled the beans.

Williamson was Deacon Jim's nephew; he sheltered his uncle before and after the killing. Miller borrowed a mare from Williamson, admitted to him that he had killed a man and threatened to kill his nephew if he talked.

Miller was traced to Ardmore, Oklahoma, where his landlady told officers the deacon had been carrying a shotgun. The trail then led to a youngster who admitted he had been paid to bring Miller to Ada. West and Allen had paid Miller his $2,000 fee through one Burrell.

Burrell was arrested in Texas and returned to Ada. Then a tip led lawmen to the breaks of the Trinity River near Fort Worth—and to Miller, who was arrested without resistance. By the first of April, he was residing in the Ada jail. Allen and West were lured out of Texas by a simple—and wholly fraudulent—wire: "Come to Ada at once. Need $10,000."

By the sixth of April, all the conspirators had been jailed. Miller, Burrell, West and Allen occupied cells in Ada. Peeler and Williamson, ready and eager to testify for the state, had been moved to another town. Allen and West were terrified that "Judge Lynch" would hurry the course of the law a little too much, accurately sensing the temper of the town. As it turned out, their instincts were excellent.

The good citizens of Ada had had enough of due process. Miller was living high on the hog in jail, shaving twice a day, changing his sheets each morning, eating steak brought in from the Elite Café and even softening the floor of his cell with carpet. He openly scorned the citizens' efforts to bring him to justice. After all, this had been tried repeatedly before, without success.

And as he had done before, Miller hired the best lawyer around: Moman Pruitt, a dynamic litigator who had never had a client executed and would win acquittals in 304 of his 342 murder cases. This was the last straw. And so, in the early morning hours of Sunday, April 19, about forty men broke into the jail, overpowered the two lawmen there and dragged Miller, West, Allen and Burrell out of their cells and down an alley into an abandoned livery stable behind the jail.

Miller's three codefendants were quickly jerked from the floor to twitch and convulse in ghastly silence. Then it was Miller's turn; the implacable men around him urged him to confess his crimes. Miller, to his credit, was

as impassive as he had been when he blew other men into eternity. He cared mostly about his dreadful record: "Let the record show that I've killed fifty-one men."

He pulled off a diamond ring and asked that it be given to his wife; a diamond shirt stud he left to the jailer for some kindness. And then, as the noose slid around his neck, Deacon Jim Miller asked for his trademark: his black broadcloth coat. "I'd like to have my coat," he said. "I don't want to die naked."

No, said the posse members. No. Maybe somebody there remembered how Bud Frazer couldn't kill the deacon when he wore the coat; maybe the posse had just had enough of this cool killer's effrontery. At his request, somebody did set Killin' Jim's hat on the side of his head, and Miller actually laughed. "I'm ready now. You couldn't kill me otherwise. Let her rip!"

The vigilantes pulled away, and at last, after Miller's convulsive struggles were over, one of the mob hung Deacon Jim's famous coat across his shoulders. "It won't help him now," he said.

And it didn't. The executioners went on home through a misty rain, leaving the four bodies still hanging alone in the gloom of the empty stable. Nobody ever found out who the mob members were. Nobody really cared. As an Ada historian wrote later, "[The lynching] can be written down as the one mob action in America entirely justified in the eyes of God and man."

If this was a bit presumptuous, it is certain that most of Ada agreed. The message to hoodlums was clearly posted, and Ada was on its way to the peace and quiet its citizens so devoutly desired. With Deacon Jim Miller gone, the world was surely a cleaner, brighter place. One respected citizen spoke Miller's epitaph, cutting cleanly through his smooth manners and churchgoing façade: "He was just a killer—the worst man I ever knew."

7

MA BARKER AND THE CENTRAL PARK GANG

After she was shot to death in 1935, FBI director J. Edgar Hoover called her a criminal mastermind, a claim Alvin Karpis, one of the most gifted bank robbers of the Depression era, openly ridiculed. Yet there is no doubt at all that Arrie "Ma" Barker raised four sons wholly dedicated to crime and was house mother to many of their friends.

She was born Arizona Donnie Clark near Springfield, Missouri; married George Barker; and gave him four sons: Herman, Lloyd, Arthur (known as Doc or Dock) and Fred. Earlier, while the family was living in southwestern Missouri, the eldest boy, Herman, compiled a juvenile criminal record that Doc quickly surpassed. In 1915, the Barker clan moved to an Oklahoma town that was acclaimed nationwide five years later as "the Magic City, young, prosperous, new oil spewing from the ground, a dream land, the most modern city in the West."

Tulsa began as a Creek village, became a cow town and later became the "oil capitol of the world." Yet the Barker place near downtown was hardly palatial. And so it was probably natural that Herman, Doc Lloyd and Fred spent most of their time at Central Park, a wide-open space with plenty of trees, which came in handy when burying the loot they stole in small-time break-ins; eventually, their dad, George Barker, moved back to Missouri without his family.

Fred was the first to do serious time, catching a ten-year maximum sentence for robbing a bank in Winfield, Kansas. While there, he met and befriended Canadian-born Albin Karpowics, whose name had been simplified to "Alvin

Karpis" by a teacher in Topeka, Kansas. Later, law enforcement officers nicknamed Alvin "Old Creepy."

When Fred and Alvin were paroled in 1931, their next stop was Tulsa, where they roomed with the Barkers. While Fred was gone, Herman killed himself while being chased by authorities after botching a 1927 robbery in Newton, Kansas. Lloyd was not in Tulsa because he was doing a life sentence for a 1921 murder across town at St. John Hospital, which then had been under construction.

Undeterred, Fred and Alvin organized a jewel heist operation in Kansas and Missouri. They killed Sheriff C.R. Kelly in West Plains, Missouri, two days after a December 17 robbery in that burg, prompting a Barker family move to Kansas City.

Law officers spotted Karpis and Fred Barker just outside Springfield, Missouri, near a place called Young's Orchard, on New Year's Day. Later, the authorities learned that the Barker-Karpis gang had moved north, and for good reason. Years later, Karpis reminisced that "every criminal of any importance in the 1930s made his home at one time or another in St. Paul." And while there, they took care of some family business.

Ma Barker's boyfriend, an alcoholic named Arthur Dunlop, turned up dead on April 25, 1932, near Webster, Wisconsin, on the most traveled route from St. Paul to Kansas City. Although many historians believe that Fred Barker and Karpis killed Dunlop, Karpis claimed in a late life memoir that local St. Paul criminals killed him as a professional courtesy. Two months later, somebody, most likely the Barker-Karpis gang, robbed a Fort Scott, Kansas bank of $32,000—a cool half million in modern money—on June 17.

"Open the vault!" Freddie yelled after removing some bad false teeth at the Third Northwest Bank, about twelve miles west of the Barker-Karpis hideout in Minneapolis. The take was $20,000 and nearly five times that amount in securities, but they killed two police officers and a civilian bystander while getting away.

Despite this, the Barker-Karpis gang organized and executed two of the largest kidnappings in history between new bank robberies.

Their first abduction target, precisely a year after the Fort Scott heist, was William A. Hamm Jr., scion of a regional beer-brewing empire from whose family Doc, Fred and Alvin extracted $100,000 on June 15, 1933. Two days later, their friend "Horseback to Cadillac" outlaw Frank "Jelly" Nash and two law officers were killed at Union Station in Kansas City. Nash had visited them on June 9 in St. Paul, just before the Hamm kidnapping.

Just six months later, on January 17, 1934, the Barker-Karpis crew kidnapped thirty-something St. Paul banker Edward G. Bremer, doubling up on the ransom. The Bremers paid $200,000 in cold, hard cash to see Ed alive again, even as the federal government began closing in on Alvin and the Barker clan.

By the end of 1934, public enemies "Baby Face" Nelson, John Dillinger and "Pretty Boy" Floyd were dead, leaving the Barker-Karpis gang survivors to face federal heat. Karpis and Tulsa native Harry Campbell were on the loose in Miami, Florida, when they learned that Fred Barker and his mother had been killed during a gunfight with the FBI on January 16, 1935, near Lake Weir, some 288 miles north. They moved on to New Jersey and eventually Youngstown, Ohio, at the time a gangster haven, where they picked up a crew and snagged a $70,000 steel company payroll—worth $1.2 million in modern money—on April 25. Karpis and several Tulsa associates robbed a train in Garrettsville, Ohio, of about $30,000 in November 1935, giving Alvin extra wherewithal to relax in Hot Springs, Arkansas, before moving on to the Big Easy.

Some twenty-eight FBI agents swarmed Alvin Karpis at about 5:00 p.m. on May 1, 1936, as he was leaving his New Orleans apartment building. Decades later, Karpis told an interviewer that just after the arrest, he could see "the gold dust twins" J. Edgar Hoover and his special assistant, Clyde Colson, peeking from around the corner of the apartment building to see whether they could safely horn in on the snatch.

Karpis spent some thirty years in prison, supposedly taught mass murderer Charles Manson how to play the guitar there and died in 1980 of a drug overdose in Spain, perhaps at his own hand, having written, "My profession was robbing banks, knocking off payrolls and kidnapping rich men. I was good at it, maybe the best in North America for five years, from 1931 to 1936." That might have been so, but he never discussed one crime he might have been involved in.

James and his wife, Willie Young, were devout Christians laboring southwest of Springfield, Missouri, who saw many disappointments in life. They had moved to a place near Frederick, Oklahoma, won in a 1902 land lottery, but returned to Missouri fifteen years later, only to have three of their eleven children turn into criminals. Paul, Jennings and Harry, who called themselves the "Young Triumvirate," didn't care for the day-to-day work on their hundred-acre farm near present-day Brookline. Among other crimes, the older two burgled three Missouri stores; Harry mortally wounded a city marshal in Missouri, bringing law enforcement to the farmhouse

door near Springfield on January 2, 1932. The firepower coming from the Young stronghold that day was so overwhelming that the county sheriff, two deputies and three Springfield police officers were killed. Historians have noted that Alvin Karpis and Doc Barker knew the Young brothers, were spotted in Springfield one day earlier and may have been in the farmhouse. Alvin Karpis didn't mention the "Young Triumvirate" in his memoirs, so no one knows to this day.

8
"MACHINE GUN" KELLY

KING OF THE
TULSA RUMRUNNERS

After making the FBI list of public enemies and getting himself captured, "Machine Gun" Kelly became sentimental. "I got my start in 1928," he whined over a decade later. "The biggest mistake I ever made was leaving Tulsa."

George Barnes once claimed that he was "king of the rumrunners" in Tulsa. And that was saying something. Tulsey Town had been a dusty stop on a cattle trail, second only to Catoosa, the hellhole of Indian Territory in booze, gambling and prostitution. That was in the years before a big oil strike at nearby Glen Pool turned Tulsa into the Oil Capitol of the World, drawing thousands of new people, many from sophisticated eastern cities. And of course, the grifters, gamblers and thieves came along for the ride.

Barnes had the quiet, easy drawl you would expect from someone who grew up in Memphis, but he was an outsider to the criminal underworld there, being upper middle class and Catholic. George became a bootlegger in high school, managed to get through two years of college and then dropped out to steal away the pretty young daughter of a wealthy businessman.

When young Mr. and Mrs. George Barnes returned from their elopement, "Daddy" bought him a series of business ventures, but even a small goat farm was too much for him to handle. When George returned to bootlegging full time as George R. Kelly and got arrested a few times, the marriage ended. He tried to begin anew in Santa Fe, New Mexico, but was convicted of illicit liquor sales on March 14, 1927, and sent to the state penitentiary for a brief stay.

He was released quickly enough to be named as a prime suspect in a Saturday night Tulsa robbery near Fourth and Main Streets on July 23, 1927. The next evening, George was arrested for vagrancy, pending other charges, but was eventually released for lack of evidence. The next year, in February 1928, he walked out of the federal court in Tulsa convicted of bootlegging again.

When he arrived at the federal prison in Leavenworth, Kansas, he met Frank "Jelly" Nash, who was part of the last train robbery in Oklahoma history only five years before. More importantly, Harvey Bailey, the "King of the Heist Men," mentored him in professional bank robbery.

George was released in 1930 and ended up in the Silicon Valley of America's Depression-era criminal elite. "Of all the Midwest cities," former Tulsan Alvin "Creepy" Karpis said in his memoirs decades later, "the one I knew the best was St. Paul, and it was a crook's haven. Every criminal of any importance in the 1930s made his home [there] at one time or another."

While there, George helped pull off a job that the *St. Paul Pioneer Press* called "one of the most daring bank holdups since the days of the Younger Brothers and Jesse James gangs." The heist, about one hundred miles west of St. Paul at Willmar, harvested $70,000, in cash—worth about $1.2 million in modern money—and as much in securities. Three of the robbers stole most of the loot from their accomplices.

One month later, they were found dead fourteen miles northeast of St. Paul. But by then, George was using his undersized share to court a new wife, who was born Cleo Brooks but called herself Kathryn. She married him on September 30.

George was in the crew that robbed $40,000 from the Central State Bank in Sherman, Texas, on April 3, 1931. And he helped take another forty at Denton, a North Texas town. After one more job in Tupelo, Mississippi, near Kathryn's birthplace, George began planning a kidnapping. On January 27, 1932, George and an accomplice grabbed Howard Woolverton and his young wife out of a car in South Bend, Indiana, assuming that his family could make good on the $50,000 ransom demand. They couldn't.

Kathryn was livid, but she had a plan. Although George Barnes didn't really like weapons, she bought him a slightly used Thompson machine gun. She then kept the bar closed at the gang hideout, a farm owned by her stepfather, Robert "Boss" Shannon, near Fort Worth, until George had finished daily target practice. After Tulsa's Barker gang collected $100,000 in ransom money for St. Paul beer mogul William A. Hamm, Kathryn, "Machine Gun" Kelly and their associate Albert Bates shrugged off a

recently bungled abduction and headed north to Oklahoma City for one more try. Their target was an oil millionaire.

Charles Urschel started as an Ohio farm boy, served in the army during World War I and then moved west to the Oklahoma oil fields, where he went wildcatting with Tom Slick and eventually married Slick's widow. Charles and Berenice realized that they might be kidnapping targets but fired a bodyguard for sleeping too much on the job and lived to regret it.

The Urschels were on the screened porch of their home in the exclusive Heritage Hills neighborhood playing cards with their friends Walter and Kelly Jarrett when the kidnapping went down on the evening of Saturday, July 22, 1933. Since the foursome wouldn't say which of the two men was Urschel, both were shoved into the getaway car. And then things really went wrong.

Since criminal wizard Machine Gun Kelly forgot to fill the getaway car with gas, they were stranded for an hour while the driver went to get some. Later, after releasing Walter Jarrett, the driver fell asleep, ran the car into a ditch and couldn't find the hideout near Fort Worth without asking for directions from a bewildered farmer, who remembered them.

Worse still, in the days to come, Charles Urschel used his photographic memory to record everything he experienced at the Ora Shannon farm. Since the gang hadn't taken his watch, Urschel timed airplanes passing overhead daily, even as his friend Charles Colcord, a frontier deputy U.S. marshal who made a fortune in oil and real estate, offered a $10,000 reward for George Kelly, dead or alive.

When the $200,000 ransom—about $ 3.6 million in modern money—arrived in Fort Worth, everyone, including Urschel, celebrated. Eventually, he was dumped on the north edge of Norman, Oklahoma, with just enough cab fare to get home.

The Kellys, no doubt, knew about the Lindbergh baby kidnapping and murder but probably didn't realize that they had now become the first suspects targeted under the new Lindbergh law, which made the Federal Bureau of Investigation the lead agency in most kidnappings. Nor did they know that Urschel had been sneaking peeks at all of them from beneath his blindfold as he recorded the critical data that led the FBI to the Ora Shannon farm on Saturday, August 12.

George and Kathryn were already on the run, but George's old mentor, Harvey Bailey, was pulled out of the outdoor hammock where he was dozing with ransom money stuffed in his pockets. Naturally, the jury didn't believe that he was innocent of the kidnapping, but this time, he probably was.

Machine Gun Kelly, off to prison. *Western History Collections, University of Oklahoma Libraries.*

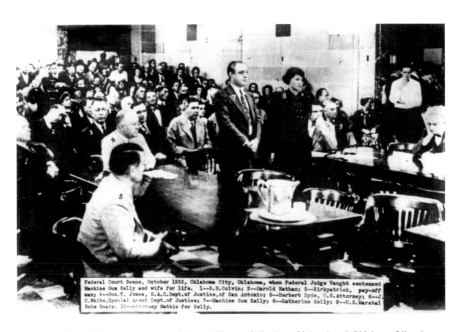

Machine Gun Kelly at sentencing. *Western History Collections, University of Oklahoma Libraries.*

Kathryn's beloved mother, Ora, was also snagged in the dragnet and thrown into a local hoosegow.

And with that, Kathryn tried to turn informant and had George write a letter threatening the whole Urschel family, even as the net began to close in September 1933.

They were hiding where everything had begun for George, back in Memphis. And neither one of them ever said, "Don't shoot, G-men," despite later FBI claims. Instead, Machine Gun Kelly quietly muttered, "I've been waiting for you all night" and put on his own handcuffs.

Thirteen days after their first appearance before Judge Edgar S. Vaught, he gave Kathryn and George life sentences. "Be a good boy," Kathryn said as George was led away. She never saw him again. Machine Gun Kelly died on his fifty-ninth birthday at Leavenworth in 1954. Charles Urschel, of all people, anonymously financed the college education of Kathryn's daughter, Pauline, with Judge Vaught acting as intermediary, despite the many times the Kelly gang threatened to kill him.

And about half of the $200,000 ransom paid to return Charles Urschel home alive has never been found.

9
BONNIE AND CLYDE

BAD SEED BANDITS

Those two give us all a bad name.
—attributed to Charles Arthur "Pretty Boy" Floyd

From the tales one hears in the Sooner State even to this day, you would think that Bonnie and Clyde were born and raised in Oklahoma. Yet Clyde Chestnut Barrow, who gave himself the middle name "Champion," and Bonnie Parker were Texans through and through. By the time they met in West Dallas in early 1930, she had been married to Roy Thornton, then residing in the state prison at Huntsville, for about four years. She wore his wedding ring to the day she died.

Clyde rustled his first stolen turkey long before he met Bonnie. Soon after they met, he was arrested for car theft and burglary in Waco, but Bonnie smuggled a pistol into the jail. Clyde escaped but was recaptured in Ohio. One week later, on March 18, 1930, he was on his way to Huntsville.

Clyde was paroled in February 1932 and began a new criminal career with Schulter, Oklahoma native Ray Elzie Hamilton. They pulled off two quick robberies in the Dallas area but killed a jeweler on April 27. During another failed robbery attempt at Kaufman, Texas, Bonnie was captured during a mule-back escape while Barrow and Hamilton ran for the Oklahoma border.

But on the old Texas Road near Stringtown, Barrow, Hamilton and a third man often identified as Ross Dyer were confronted by Sheriff C.G. Maxwell on Friday, August 5, at a dance outside a roadside country store that still stands. Hamilton and Barrow killed Maxwell and wounded Deputy

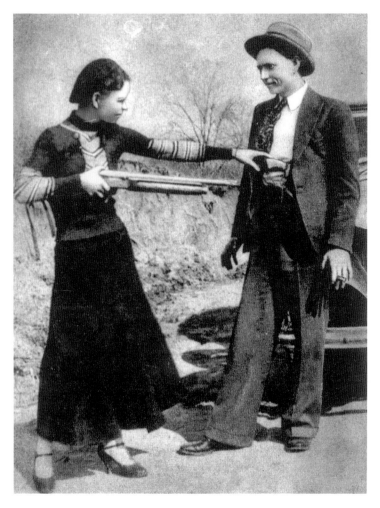

Bonnie and Clyde, clowning. *Western History Collections, University of Oklahoma Libraries.*

Eugene Moore. By mid-January 1933, they had killed two more law officers and a grocer in Texas.

That March, Clyde's brother Marvin "Buck" Barrow was released from prison. Nearly two years earlier, in early July 1931, he had married Blanche Caldwell near America, Oklahoma. So now, Bonnie, Clyde, Blanche and Buck journeyed to Joplin, Missouri, where they rented a two-story garage apartment (which still stands) in early April. The neighbors suspected they were bootleggers and called the cops when Clyde accidentally fired a BAR automatic rifle while cleaning it. The Barrows killed two Joplin officers as the

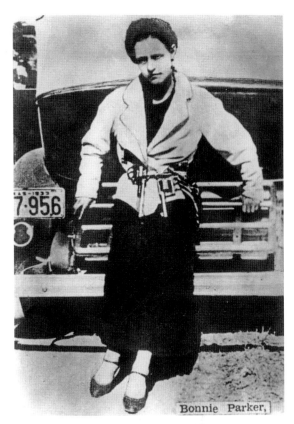

Right: Bonnie Parker, suitably armed. *Western History Collections, University of Oklahoma Libraries.*

Below: Buck Barrow, clueless. *Western History Collections, University of Oklahoma Libraries.*

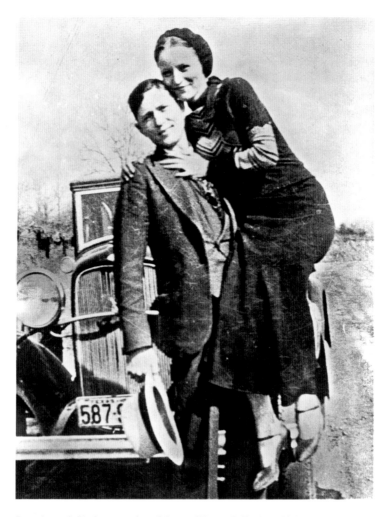

Bonnie and Clyde, mugging. *Western History Collections, University of Oklahoma Libraries.*

gang escaped; in the next two months, bank robberies in Indiana and Minnesota were attributed to them.

More certainly, on June 11, while speeding toward a bridge near Wellington, Texas, Clyde missed a turn in the road, nearly killing Bonnie in the burning wreck that followed. They kidnapped two Wellington lawmen and then sped toward Erick, Oklahoma, some forty miles to the north, but the Barrows weren't quiet for long.

Two weeks later, they raided a National Guard Armory at Enid, collecting automatic rifles, over forty pistols and thousands of ammunition rounds for

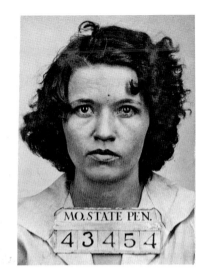

Blanche Barrow, "rid hard and put away wet." *Western History Collections, University of Oklahoma Libraries.*

the robberies and gun battles that quickly followed before heading north. The Barrows tried to nurse Bonnie back to health in Fort Smith, Arkansas, but had to leave town when new gang associate W.D. Jones killed the town marshal of nearby Alma. Soon, they tried to do a hit-and-run robbery in Fort Dodge, Iowa; robbed a few gas stations; and even took hostages before heading south.

Platte City, Missouri, some 320 miles to the northeast of Enid, was among their first destinations. Now a bustling Kansas City suburb, Platte City was then a quiet town of six hundred. The Red Crown Tourist Court just outside town featured practically new tourist cabins, the best restaurant in the area and even a ballroom. None of this mattered to Clyde Barrow when they arrived on the evening of July 18 since he was simply too tired to go anywhere else. The next day, a suspicious druggist sold Clyde some bandages for Bonnie and then called the police. But Blanche Barrow sealed their fate the next day when she strode into the Red Crown Restaurant sporting fancy red riding pants.

The gang escaped in a gunfight that began in the early hours of July 20, but Blanche was never able to use her left eye again. Worse still, Buck suffered a mortal head wound from which he died five days later. They were captured while Clyde, Bonnie and Jones escaped.

According to one account related decades later, sometime after November 1933, Bonnie and Clyde arrived in Sallisaw, Oklahoma, and tried to contact

Charles Arthur "Pretty Boy" Floyd, who refused to help them. Despite this rejection by Oklahoma's leading bandit, in the five months that followed, the Barrows escaped an ambush and two posses; organized a prison escape near Huntsville, Texas, to spring Clyde's friend Henry Methvin; killed two prison guards and two police officers; and committed four robberies.

The morning of April 6, 1934, Bonnie, Clyde and Methvin were slumbering just outside Commerce, Oklahoma, twenty-seven miles southwest of Joplin, Missouri. Local constable Cal Campbell and police chief Percy Boyd had received reports that several people were sleeping in a Ford just off a state road leading to the Crab Apple Mine. Sixty-six-year-old Campbell had little experience in law enforcement, but with five mouths to feed and a Depression underway, he welcomed any work he could find.

Clyde spotted the law officers approaching and quickly stepped on the gas but ran the Ford into a ditch instead of onto the highway just as Campbell and Boyd got out of the police car. Campbell managed to draw his pistol, but Clyde was much quicker. While riding with the gang later toward Fort Scott, Kansas, where he was released, Chief Boyd knew that he was lucky to be alive.

No one knows for sure, but there is some evidence that the Barrow gang drove south to Tulsa, where they may have stayed with Willis Newton, whose gang had pulled off the greatest train robbery in American history ten years earlier, near Chicago. While there, Clyde, or someone using his name, mailed a letter from the downtown post office:

Tulsa, Okla.
10th April
Mr. Henry Ford
Detroit Mich.

Dear Sir:
While I still have got breath in my lungs I will tell you what a dandy car you make. I have drove Fords exclusively when I could get away with one. For sustained speed and freedom from trouble the Ford has got every other car skinned and even if my business hasn't been strickly [sic] *legal it don't hurt anything to tell you what a fine car you got in the V8—*

Yours truly
Clyde Champion Barrow

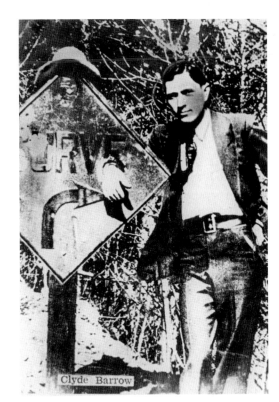

Right: Clyde Barrow, with a dead sign. *Western History Collections, University of Oklahoma Libraries.*

Below: The posse that did in Bonnie and Clyde. *Western History Collections, University of Oklahoma Libraries.*

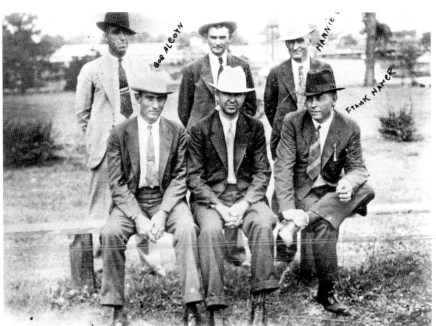

In the years since, would-be experts have debated whether this letter or another endorsement signed "John Dillinger" and mailed seventeen days later were fabrications. One such expert remarked that the Barrow letter bears a striking resemblance to Bonnie Parker's handwriting and might be authentic. More certainly, Bonnie, Clyde and Methvin surfaced near Gibsland, Louisiana, on Monday, May 21, 1934.

Texas bounty hunters and local lawmen knew where to find them, and that was no coincidence. Henry Methvin's father had been approached by Louisiana law enforcement and convinced to cooperate on the promise that Henry would escape the death penalty. Early that Monday evening, the Barrow crew drove into nearby Shreveport. While Henry was inside a restaurant ordering carryout, Clyde spotted a police car on routine patrol and drove away, leaving Henry to fend for himself.

Later that night, the posse began watching the Methvin family home eight miles south of Gibsland, but Bonnie and Clyde didn't surface until the morning of Wednesday, May 23. Clyde slowed to look at the old man's truck jacked up on the side of the road near the Methvin place with one tire missing. Rifles blazed, and gunfire echoed through the trees as the star-crossed lovers slumped into death. Later, retired Texas Ranger Frank Hamer claimed that the posse had given Bonnie and Clyde a chance to surrender.

And maybe it was true.

"PRETTY BOY" FLOYD

He was a farm boy from Georgia whose earliest crimes were stealing cookies from a general store and later helping other teenagers switch infants from one baby crib to another in the back of a revival tent. He grew up on a farm in the Akins community near Sallisaw, Oklahoma, a town that John Steinbeck wrote about in *The Grapes of Wrath*. Children like Charles Arthur "Charley" Floyd grew calluses there tilling the soil, while some of their fathers "farmed in the woods" making moonshine. His father, Walker Lee Floyd, was one of them.

And in the evenings, boys like Charley listened to stories of bank and train robberies, gun battles and vigilante justice from the nearby Cookson Hills and beyond. Charley himself particularly admired Emmett Dalton, the only survivor of the disastrous 1892 raid on Coffeyville, Kansas, in which the Daltons tried and failed to rob two banks at once.

Since Charley hated hard work in general and cotton picking in particular, he chose another path. He stole $350 in pennies from the post office inside the Akins general store. Three years later, in August 1925, little more than a year after he married Ruby Hargraves, Charley left the Cookson Hills pistol in hand, headed for St. Louis and returned the next month with a new bank-robbing partner named Fred Hildebrand. They were sporting new suits and driving a fancy Studebaker roadster. Two days earlier, with another man, they had robbed a payroll courier of $2,000 in cash from the Tower Grove Bank of St. Louis. A few days later, Charley was arrested and returned to St. Louis. On December 8, he was sent to the Missouri State Penitentiary.

The state prison at Jefferson City offered dim cells and darker prospects for the prisoners who worked twelve-hour days in conditions that outside observers called slave labor.

While there, Charley learned high-end criminal skills from St. Louis and Kansas City safecrackers, burglars and armed robbery specialists. After he was released on March 7, 1929, he was spotted in Kansas City by the local police, arrested on vagrancy charges and told in no uncertain terms to head for Oklahoma.

He became an oil field roustabout in Earlsboro, Oklahoma, but was fired when the bosses learned about his prison record. Charley began running bootleg whiskey to Oklahoma and elsewhere from Kansas City, where he was arrested for vagrancy in May, only to be arrested later in Colorado on similar charges. Worse, his father was shot to death in an argument over some lumber in mid-November, prompting Charley to head north.

"Where did you come from, pretty boy?" Legend has it that a madam named Annie Chambers asked Charley this question, but it was Beulah Baird Ash who spotted him during a December 1929 card game in a Kansas City hotel that catered to criminals on the run. She became Charley Floyd's girlfriend fifteen months later, when her husband, Wallace Ash, and his brother William turned up dead. But now, in January 1930, Charley had started the next phase of his criminal career in Ohio.

When he robbed the bank at Sylvania, ten miles northwest of Toledo, on February 5, 1930, five men came in yelling, "Hands up!" while two confronted the cashier. Even though the safe was locked, the gang scooped up about $2,000 ($11,400 today) just as an alarm was sounded. Minutes later, a fire truck with its siren wailing chased them out of town. The firemen got the license number but lost them in traffic.

Charley was casual in small towns. While the getaway driver kept the motor running, the Floyd gang crashed through the door and yelled, "Hands up!" Cash in hand, they left with two or three bank employees standing on the running boards to discourage the police from shooting, with Charley saying, "Hold on tight and don't you worry." Some fifty years later, Elmer Steele, one of their drivers, claimed that he saw Charley tear up a few mortgages. Well, maybe, but it's hard to imagine taking the time to find and destroy all that paper when the law might be just down the street.

Floyd was arrested on March 8 in Akron, Ohio, for robbing the Sylvania Bank. On Wednesday, December 10, 1930, he was on a train from Toledo bound for the Ohio State Penitentiary in Columbus. The guards left the passenger car for just a minute, and that's all it took. He rolled over the

prisoner to whom he was chained, broke the chains, ran for the bathroom, busted out a window and jumped down a steep embankment into thick, tall grass near the little town of Kenton. The guards stopped the train and walked just a few inches from him. But Pretty Boy was too deep in the tall grass for them to find him. When darkness fell, he began the long walk to the safety of criminal havens in Toledo.

Back in Oklahoma, Floyd was universally admired by his neighbors, who didn't mind him robbing banks. Few in the rural American Southwest saw much wrong with robbing the moneyed men who owned banks and railroads. This was especially so in Oklahoma, which had more bank robberies than any other state in 1912, thanks to outlaws such as Al Spencer, Jelly Nash and Henry Starr, who were inspired by the Reconstruction exploits of Frank and Jesse James. Henry Starr had been killed in 1921 during one of the first attempted bank robberies by automobile in American history. A *True Detective* magazine writer who rode with policemen and sheriffs looking for Floyd during the summer of 1932 claimed that the country people of eastern Oklahoma clammed up whenever they were asked about Floyd's whereabouts.

In January 1932, the Oklahoma Banker's Association claimed that the people in eastern Oklahoma were protecting Pretty Boy, and they were probably right. Oklahoma bank insurance premiums had doubled over the past year, and Lieutenant Governor Robert Burns called a "council of war on banditry" that month, saying, "Floyd has terrorized the entire east central district of Oklahoma. Already six killings and ten bank robberies have been charged to his gang. He must be stopped." Burns was exaggerating the numbers but promised to make machine guns and automatic rifles available to law officers.

Eventually, Charley robbed at least sixteen banks, an American record exceeded by only two men: Alvin Karpis of the Barker gang and John Dillinger. The only killing Charley ever talked about was a former sheriff whom he killed in early April 1932. "Erv Kelley nearly got me," Floyd said later. "There was only one thing to do. It was either him or me, so I let him have it. He had the same idea I guess. We fired at the same time. I never saw Kelley until he was falling. I fired five shots…and four of his shots hit me, one hitting me on the right hip and hitting a gun. The bullet hit the gun but it did not hit me."

Seven months later, on November 1, the Floyd gang drove into Sallisaw with newbie Aussie Elliott at the wheel and Floyd's longtime partner, George Birdwell, shining up his Thompson machine gun in the back seat. Their

arrival was hardly a surprise. In fact, Floyd's grandfather Charles Murphy Floyd, several of the old man's cronies and other Floyd family members were in town that day for the occasion. When the bandits stopped in front of the two-story red-brick Sallisaw State Bank, Charley sported a new suit and shined shoes as usual. He bounded into the barbershop next door, warning everybody to stay away from the telephone. "We're gonna rob the bank," Charley told everybody within earshot. One old farmer encouraged him to "Give 'em hell!"

While his crew scooped up $2,350, hardly the best take of his career, Floyd shook hands all around, put a banker on the running board and told him to "hold on tight," even as six packages of nickels and half dollars broke open and scattered on the sidewalk. Some five blocks later, they slowed down for the banker to jump off.

When it was over, more than a few people in Sallisaw wondered how police chief Bert Cotton could have missed the robbery since he was parked only seven car lengths from the bank. No matter, the county attorney, Floyd's childhood friend Fred Green, vowed to prosecute Floyd to the full extent of the law if he was captured.

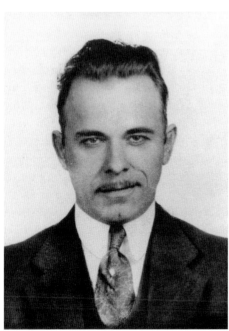

Smug John Dillinger. *Western History Collections, University of Oklahoma Libraries.*

That would not be easy. Floyd and Adam Richetti robbed a bank in Mexico, Missouri, on June 14; killed a sheriff in Bolivar; and drove on to Kansas City, where law officers spotted them. While there, on June 17, 1933, three or perhaps four gunmen ambushed several lawmen and Floyd's old associate Frank "Jelly" Nash in the Union Station parking lot. Nash and four law officers were killed. Three days later, after being publicly named as a suspect, Floyd sent a postcard from Springfield, Missouri, to the Kansas City police denying involvement. Even so, three months later, Floyd and Richetti went into hiding near Buffalo, New York.

After John Dillinger was killed in Chicago on July 22, 1934, the FBI made Floyd public enemy number one. Since he had been suspected as a participant in a shootout near Springfield, Missouri, on January 2, 1932, in which six law officers were massacred, he was already on Hoover's short list even before Kansas City thug James La Capra claimed that underworld henchman John Lazia had arranged for Adam Richetti and Floyd to help rescue Nash from the FBI.

FBI agent Melvin Purvis flew to East Liverpool, Ohio, the very evening of the day in October 1934 when Floyd was spotted with Richetti and some girlfriends who were helping them spend their bank robbery money. Floyd spent his spare time cooking spaghetti and baking pies. On October 13, the *Buffalo Courier-Express* ran a front-page story on Pretty Boy, which made him extremely nervous. He and Richetti pointed their Ford for Hell's Half Acre, an outlaw haven not far from East Liverpool, Ohio, on the Pennsylvania border, where State Line Jenny operated a saloon.

Pretty Boy and Richetti robbed a bank in Tiltonsville, Ohio, on October 20, taking $500. On the way out, Floyd told a scared little girl who was crying not to worry. But then they wrecked the Ford in a fog bank and were turned in to local police. After a quick gunfight near Wellsville, Richetti was captured, but Pretty Boy escaped.

Floyd offered a farmhand named Peterson ten dollars to drive him to Youngstown, but Peterson's car soon ran out of gas. Floyd then commandeered another car and forced a florist to drive him toward Lisbon, Ohio, the northernmost town that saw combat during the Civil War. They avoided a roadblock at Lisbon but were chased by two deputy sheriffs into the countryside. After a brief gunfight, Floyd fled into the trees.

The next afternoon, Sunday, October 21, Richetti was positively identified, prompting Melvin Purvis to fly into Wellsville that night. He knew that Floyd was not far away. At about noon the next day, Charley paid for a lunch at the farmhouse of Robert Robinson near East Liverpool and moved on. But the Robinsons told a local constable, who relayed Floyd's description to a Federal Bureau agent working at the East Liverpool police station. At about three o'clock, Floyd arrived at the farm of Ellen Conkle, a widow whose land was between the towns of Clarkson and Calcutta, Ohio. "Lady, I'm lost and want something to eat, can you help me?" He was unshaven, his shoes were scuffed and he told Ellen that he'd been drinking and hunting squirrels.

She fed him spare ribs, potatoes, fresh bread, pumpkin pie and coffee. Pretty Boy skipped the rice pudding but read the *East Liverpool Review*, which featured an article about the massive manhunt Melvin Purvis was conducting

to find him. He said the dinner was fit for a king, paid her one dollar and decided to wait for her brother Stewart Dyke, who was husking corn out back. He wanted a ride to Youngstown.

Floyd climbed into the driver's seat of the Model A Ford Stewart Dyke had parked next to a corncrib and began looking at a map. At 4:00 p.m., Stewart and his wife approached the car after finishing the day's work; they refused to take him to Youngstown but agreed to take him into nearby Clarkson. Just as the car began moving, two Chevrolets full of law officers scouring the country for Floyd hove into view on Sprucevale Road. Melvin Purvis was in one of the cars.

Floyd ordered Stewart to drive to the very back of the corncrib, which was a shed elevated above the ground by eight concrete pillars. Floyd cursed, pulled his gun and ran under the corncrib, but then he started running across the pasture behind the house toward some nearby woods. By the time the law officers yelled for him to halt, he was five hundred feet away on the crest of the hill, darting left and right.

Lawman Chester Smith had been a sharpshooter during World War I. He knocked Floyd to his knees with the first shot, but Floyd got up and started running again. A second shot hit him in the side and brought him down to stay.

After a few questions about the Kansas City Massacre that Floyd wouldn't answer, Purvis asked if he was Pretty Boy. "I'm Charles Arthur Floyd," he said, just before he died.

He was thirty.

THE FAIRFAX TERROR

William King Hale had a strong ego but weak eyes. He first squinted at present-day Osage County while punching Texas cattle in about 1900. No one knows why, but he returned in a few years and began ingratiating himself to his neighbors with favors large and small. By 1923, he had leased some forty-five thousand acres of good grazing land and owned another five thousand acres outright. In his spare time, he operated the Big Hill Trading Company, Big Hill Undertakers and a bank in Fairfax, a western Osage County town started twenty years earlier. He was a flush-faced, goggle-eyed six-footer who couldn't see anything without glasses, yet he often posed for pictures with his prominent jaw jutting straight out. Hale virtually fathered two nephews, Ernest and Bryan Burkhart, who had moved north from Texas at his suggestion.

The Osage had been forced into Oklahoma following an 1872 congressional act requiring the sale of all their tribal land. The next year, the U.S. commissioner of Indian affairs duly reported that the three branches of the tribe had established communities at Pawhuska, the tribal capital; Hominy; and Gray Horse, near present-day Fairfax.

Chief James Bigheart signed the first Osage oil lease in 1896, setting the stage for the first production the following year and fabled millions in revenue for his people over time. The 1906 Osage Allotment Act created "head rights" entitling each enrolled member of the tribe to equal shares of any income from tribal property. The tribe no longer owned any surface rights but had retained mineral (e.g. oil and gas) interests in

the "underground reservation" beneath the surface of the Osage Nation. Curiously, in the early years, the head rights could be inherited by persons outside the Osage tribe, at the very time when the full bloods were being absorbed into the white population.

The 1910 U.S. census recorded 591 full bloods in a tribe that had dwindled to 1,373 individuals at a time when it was not uncommon for an Osage family to have three head rights and an income of $25,000 (about $625,000 today). Sixteen years later, the *Literary Digest*, an influential weekly magazine of the time, noted that "the Osage Nation is a stomping ground of the badmen, bandit card sharks, former cow-punchers now looking for an easy living, gamblers and roustabouts."

Hale's nephew Ernest Burkhart had a taste for just that kind of thing. He had been a Fairfax taxicab driver before marrying Mollie Kyle (sometimes Kile), whose mother, Lizzie, was an allotted full-blood Osage living with the couple. Later, some Osage County wags observed that a few timely deaths might give Ernest access to some $500,000 in annual head right income. The first to die was Anna Brown, Ernest's hard-drinking sister-in-law. Anna was found dead near Fairfax on May 29, 1921, about one week after Ernest asked Anna to help care for the ill-fated Lizzie Kyle in Gray Horse. Although local doctors performed a quick autopsy on Anna's alcohol-sodden corpse, they somehow missed a bullet in her brain, which an undertaker found later. Less than two months after that, in July 1921, Lizzie died of causes unknown at age seventy-six, leaving her four head rights to her daughter, Mollie Kyle Burkhart, and Lizzie's last surviving sister, Rita, who was married to Bill Smith.

By 1926, Pierce-Arrow automobiles had long replaced bows and arrows in many Osage households. Still, Mollie's tall, distinguished-looking first cousin, forty-two-year-old Henry Roan, kept to some of the old ways, such as keeping his long black hair plaited. After discovering that his wife was having an affair with a white man, Roan began leaving home for drinking sprees that would sometimes last a month. And in late January 1923, he left home for good.

A young boy found Henry on February 6, slumped over the steering wheel of his car five miles northwest of Fairfax, parked beneath two saplings on a country road. Later, law officers found a bullet hole behind his left ear. He'd been dead about ten days. William King Hale served as one of Henry's pallbearers as Henry's cousins Mollie and Rita looked on.

Fairfax was a quiet town in 1923, but that all changed in the early morning hours of March 10, when Rita and Bill Smith's house exploded, about one

hour after Bill Smith and Nettie Brookshire, their teenaged white servant, arrived home after a late Friday night out.

Nettie and Rita were instantly torn to pieces. Their bodies were scattered as far as three hundred feet away. Bill lived four days without regaining consciousness, but in the months before his death, he had said plenty.

Smith had claimed that William King Hale was at the center of a conspiracy. That conspiracy was the theory of cases finally prosecuted many years later. The prosecution contended that Hale had planned to murder all of Mollie Burkhart's Osage relatives, consolidate their wealth in Mollie's hands and eventually kill Mollie and Ernest Burkhart.

Ernest's brother Bryan Burkhart had taken care of an additional problem during the early hours of May 22, holding Anna Brown as Kelsie (Kelsey) Morrison shot her in the back of the head. She was pregnant and had told her friends that Bryan was the father, even though some wags claimed that Bill Hale himself got her pregnant. Whoever was the father, the Burkhart brothers and several friends took Anna to several speakeasies on the evening of May 21 and then drove to a ravine some three miles west of Fairfax, where Bryan kissed her as Kelsie Morrison pulled the trigger.

During the inquest that followed, Bryan claimed—and his brother Ernest corroborated—that they drove her from Mollie and Ernest's place back to her home at five o'clock in the morning. Initial charges against Bryan were dropped for lack of evidence.

Henry Roan had been killed by John Ramsey, a bootlegger then in his forties who had befriended him, listened to Henry's complaints about his unfaithful wife and treated him to several drinking sprees before luring Henry to a remote spot with promises of whiskey and killing him.

Ramsey also killed Rita Smith; her husband, Bill; and their white servant with help from Asa "Ace" Kirby after Bill told neighbors outside his ranch near Gray Horse that he knew who had ordered the deaths of Anna Brown and Henry Roan. Smith also sued Hale for $6,000 (about $82,000 in modern money).

The explosion of the Smith house in the early hours of March 10, 1923, prompted the Osage Nation and several civic organizations in Pawhuska to petition the Department of the Interior for help. Interior turned to FBI director W.J. Burns and his twenty-eight-year-old assistant, J. Edgar Hoover. The investigation was difficult. Since most Osage were afraid to cooperate, the FBI sent amiable undercover agents who were from the area or familiar with it as an insurance agent, a cattleman, an

oil prospector and a Native American medicine man. The agents worked through the three hundred or so Fairfax citizens looking for clues.

They confirmed that Henry Roan had been murdered on an Osage homestead allotment, which gave the federal government jurisdiction to investigate and prosecute the crime. They also learned that just before the Smiths were killed, ten quarts of nitroglycerin used to fracture rock at the bottom of oil wells had been stolen some twenty miles north of Fairfax, near Shidler. The agents interviewed hundreds of people, many of whom described Hale as a gang leader. Yet the actionable leads were few, and the false trails were many. Of course, the initial suspect was Roy Bunch, who had been having an affair with Roan's wife, Mary, but soon the investigators moved on to other leads.

Hale somehow learned about the investigation but told friends that the Bureau was slow and had no jurisdiction. But by January 1926, the bureau had enough evidence to take on the king of the Osage Hills.

Ernest Burkhart ratted out John Ramsey for the Henry Roan murder. And Ramsey implicated Bill Hale to avoid the electric chair. After a series of trials conducted in Guthrie, Oklahoma City, Pawhuska and Bartlesville, which began in June 1926, Ernest was the star witness against Hale and Ramsey, who were convicted of murdering Anna Brown, Henry Roan, Bill and Rita Smith and young Nettie Brookshire.

Hale and Ramsey were paroled in 1937, but Ernest Burkhart was not released until October 1949. Some of Hale's associates died in mysterious circumstances not explained to this day. Ace Kirby, who helped bomb the Smith house in Fairfax, was shot to death in an attempted burglary. Someone had tipped off the store owner.

By some accounts, between twelve and twenty-four murders possibly attributable to William King Hale, "the king of the Osage Hills," remain unsolved to this day.

ZIP WYATT

WANTED ALIVE BUT NOT DEAD

The dying man with black hair, piercing dark eyes and a beard, propped up by two pillows, looked right into the camera a few days after he was shot and captured. He'd been surrounded a few miles southwest of Marshall, Oklahoma Territory, the hometown of the Sooner State's greatest historian, Angie Debo, who had moved there with her parents five years earlier. His stare was intense and his fate hopeless, the formidable bars on the jail window clearly visible just above his head. He'd been chased by five separate posses and escaped each time, until he crept into that cornfield just outside Marshall on Sunday, August 4, 1895.

His notoriety was great, but his days were few, as Nathaniel Ellsworth "Zip" Wyatt, who sometimes called himself Dick Yeager, waited for death in that shabby Enid jailhouse. He became the hottest headline in the *Oklahoma Territory Press*. The state and federal authorities there all wanted him when Zip was on the run, but not after he died at the jail in Enid on Saturday, September 7. In fact, U.S. marshal E.D. Nix refused to pay Zip's last medical expenses since county authorities had refused to give him up. After all, some $5,000 in reward money had been hanging on his head. And nobody was there to see him buried nearby the next morning, except a little dog that trailed behind the burial party, even as elsewhere Zip's relatives fought over his belongings.

Zip was born into a family of ten in 1870. He was the son of a shiftless, hard-living Indiana Civil War veteran who had moved west and settled near Guthrie at about the time of the 1889 land run. One of Zip's older brothers

had gone bad first, becoming "Six Shooter Jack" Wyatt, a professional gambler who left home early only to be shot and fall dead on a gambling hall table in Texline, Texas, in 1891.

Zip had trouble of his own that year. In June 1891, he shot up Mulhall, Oklahoma Territory, just for the fun of it. Later, in Pryor's Grove, Kansas, on July 4, 1892, he killed Kiowa County, Kansas deputy sheriff Andrew W. Balfour, who had attempted to arrest him on Kansas larceny charges at a horse race.

In one problematic version of events, a circus was also in progress that day. An entertainer known to history only as the "Great Gamboni" supposedly fell from his high wire to the ground as the shooting occurred. All too conveniently, Zip later claimed to have been "the only bad man who ever brought down a bicycle rider" as he was cuffed. Perhaps this was so.

Whatever the circumstances of the Balfour murder, Zip fled to his home state of Indiana only to be captured several months later in Terra Haute and returned to Guthrie. Confined in the jail there, he somehow escaped through a sewer pipe during a New Year's Eve Salvation Army prayer service. One version of events has him sawing through his cell bars with a blade brought to him in a cake.

And with that, Zip dropped from public view until his rumored but never proven two-for-one robberies of a general store and adjoining post office in Arapaho, Oklahoma Territory, in November 1893. Seventeen months later, he was shot dead—or so it was thought. William Blake, the man killed by deputy U.S. marshals following a train robbery in early April 1895 near present-day Dover, Oklahoma, was in fact a thirty-three-year-old Doolin gang member from Kansas better known as "Tulsa Jack." Eventually, the mistaken identity was corrected, but some suspected then that Zip and his partner Isaac (Ike) Black had been with Doolin in Dover. No one knows for sure to this day.

Yet another general store and post office robbery followed on June 3 in Fairview, a town in far western Oklahoma Territory that no longer exists. A posse trapped the suspects with two women the next day on the present-day Woods–Blaine County line, but the men escaped. When captured, Ike's wife, Belle, and Jenny Freeman had store goods that had been taken from Fairview.

The trail went cold for nearly two months, but then, on July 26, two men robbed the post office and general store in Oxley, a ghost town then six miles northeast of Watonga in Blaine County. This time, Zip Wyatt and Ike Black robbed someone they knew. Postmaster A.B. Laswell promptly notified the authorities.

Although a posse found Wyatt and Black early the next morning in nearby Salt Creek and scared away their mounts, the outlaws escaped again, stealing some horses and a cart on the morning of July 27. Anti–Horse Thief Association members meeting nearby that evening joined the pursuit.

In yet another daybreak attack, the association posse trapped the pair in a canyon. An army veteran named Jack Ward claimed that he shot Wyatt twice in the chest before he rode away, apparently thanks to a bulletproof vest beneath his clothing.

Wyatt's fourth escape came three days later, but Ike Black wasn't so lucky. They'd stopped at a shack near Cantonment, an army supply depot established in 1879 but by then abandoned, near present-day Canton. Yet another posse, this one led by Deputy Sheriff Marion Hildreth of Woods County, spotted their horses outside the shack and surrounded the place.

They were arguing about a plug of tobacco as they emerged from the shack, but they didn't quarrel for long. Although Wyatt escaped with a chest wound, somebody in the Hildreth posse killed Black with a head shot. He died with only a picture of his wife and $1.50 in his pocket.

Zip forced a doctor near Cantonment to treat his wound and paid him by stealing a horse. But soon the horseback ride was too painful, so he forced a young boy in a wagon to drive him twenty-five miles to the northeast. After the boy drove them across the Cimarron, Zip let him go but stole the rig and headed east again.

He was spotted crossing a Rock Island Railroad track five miles south of Enid, but his pursuers had no way of knowing that his destination was a ranch on Skeleton Creek, where Zip had hoped that a friend named Taylor could give him yet another horse. Zip had abandoned the horse and wagon and stolen yet another horse just after sundown on Saturday, August 3, this time from John Daily, whom he forced to ride along well into the night. Little wonder, then, that when Zip let him go, Daily galloped off to find help. And yet another Anti–Horse Thief Association posse was more than willing to join the chase.

They found Zip in a cornfield seven miles southeast of Marshall, sprawled on his stomach with a Winchester near one hand and a pistol near another. That's when Zip made the biggest mistake of his life, reaching for both even as two posse men drilled bullets into his pelvis and stomach. "For God's sake, don't kill me!" Zip yelled.

But it was far too late.

13

THE UNCHRISTIAN CHRISTIAN BOYS

Most western bad men probably turned crooked simply out of laziness and the lure of wallowing in money without working very hard; a farm boy could quickly tire, as one of them delicately put it, "of following a mule's behind all day." The same was true of eating longhorn dust morning to night. Some, like the James boys, got addicted to excitement during the war and never returned to the paths of peace. Some turned outlaw because it made them feel like somebody important.

And a few of them were simply born bad.

Like the Christian boys, brothers Bill and Bob. In 1891, their family moved from Texas into the open land north of the Canadian River and settled in what would become Pottawatomie County, Oklahoma Territory. This wild area was the land of the "saloon towns," wide-spots-in-the-road like Violet Springs, Young's Crossing, Keokuk Falls and the Corner, a tiny patch of land on the South Canadian River. Their saloons attracted the trash of the territory.

Violence was endemic. Keokuk Falls was known for its "seven deadly saloons." At the Corner lived a patient doctor named Mooney, who treated dozens of casualties from gunshots, knifings and violent batteries. He once did an amputation on a saloon table while a drunk held a lamp to light the doctor's work and revelry continued all around him.

Violence was a way of life. In Keokuk Falls, somebody shot a saloonkeeper named Haning in the head, left him on the floor of his bar and then came back later, "between daybreak and sunrise," to finish the job by driving a

rusty nail into his ear. When trains of the Choctaw, Oklahoma and Gulf Railroad stopped in Shawnee, the conductor soothingly announced: "Shawnee! Twenty minutes for lunch and to see a man killed."

These towns were hellholes, and they died hard. Even after Violet Springs was moved in its entirety to Konawa, its saloons carried on until all of Oklahoma went dry in 1907. At the turn of the century, the Pottawatamie country boasted more than sixty saloons and two distilleries. Shawnee's daily booze intake for some 3,500 souls in 1903 was estimated at twenty-five gallons of whiskey and seven hundred gallons of beer. The county was heaven for career outlaws like the Daltons, brothers Jim and Vic Casey, Bill Doolin, Zip Wyatt and inept amateur bandits like Al Jennings. With Indian Territory on two sides, the county was ideal as a base for the bootleggers who ran prohibited hooch into Indian lands. It was here that the venerable term "bootlegger" may have had its genesis, describing those smugglers who rode into Indian country with pint bottles of John Barleycorn stuffed into the tops of their boots.

Surprisingly, many good people lived here, too. The Pottawatomie country was known as "a fine country for the poor man," where crops grew well and game abounded, where one little town was named "Moral," for its first citizen decreed no booze would be tolerated in his peaceful community. And the Anti–Horse Thief Association did what it could to curb rampant livestock theft, decreeing that all horses must be branded with a "c" on the left jaw and have papers. Woes betide the man who rode a branded horse but had not the proper papers for his nag.

The Christian family was numbered among the honest folk, well respected in the county. The brothers proved to be black sheep, however, and won an early and unenviable reputation as whiskey runners and horse thieves by the time Bob and Bill were in their twenties. The Christian boys headquartered in Andy Morrison's saloon in Violet Springs until Andy was murdered while sleeping in his own back room. And in 1895, the brothers graduated from small-time crime to killing.

It happened in April 1895 in the town of Burnett (though there is also a story that the whole sordid affair happened up in Guthrie, north of Oklahoma City). It came to pass when the brothers and a drinking buddy, one John Mackey, walked out of Doug Barnes's saloon and found the law waiting for them. Deputy Will Turner (or Turney) had warrants for the brothers' arrest and thought he was tough enough to try to bring them in single-handed. Turner didn't count on the brothers and Mackey all drawing on him at once. He died in the dusty street.

Tough sheriff Billy Trousdale ran down Mackey, and the Christian boys turned themselves in—not at all a good idea. The court reporter who recorded the case remembered that a "horde of people attended from the Four Corners District, and were about the hardest looking lot in my experience." Disreputable audience or not, however, the brothers were convicted.

One story relates that the presiding judge was J.D.F. Jennings, who "was angry with the Christians because they had killed a friend of his famous son Al, one of Oklahoma's more celebrated but inept outlaws." Or maybe the judge just didn't like murderers. Whatever his mood, this tale relates, he gave the Christian boys life sentences and shipped them off to the Oklahoma City calaboose to await shipment to the pen.

Well, maybe, but more probably the boys were tried and sentenced by Judge Henry Scott, and the court reporter remembered that Judge Scott gave the brothers twenty-five and twenty-two years for the killing. The *Oklahoma City Oklahoman*, however, told its readers that the Christians had been sentenced to eight and ten years. In later days, Jennie Cantelou, the court reporter, remembered the sentences as quite lenient, recalling, perhaps inaccurately, that the deputy had been "killed from ambush."

After sentencing, whatever their terms actually were, the pair was transferred to jail in Oklahoma City, then a two-story building fitted out with interior steel cages and thought to be a solid, secure lockup. Confined at the same time, in the same cell, was a nineteen-year-old bad hat called Casey, who, with his brother, had murdered Deputy Marshal Sam Ferris over in Canadian County in the later part of May.

One Casey—either Jim or Vic, depending on what account you read—had been shot up in the fight with the deputy and later died. But the surviving brother—the *Daily Oklahoman* said it was Vic—was going to stand trial for murder. He was due to be released on bond but apparently didn't care to wait.

Since neither he nor the Christians wanted any part of prison, Bob prevailed on Jessie Finlay, his girlfriend, to smuggle in several guns, which he stashed in the stovepipe inside his cell. The outlaws chose Sunday, June 30, 1895, to make their break, for on Sundays, the jailer, J.H. Garver, allowed his prisoners to move about in the corridor outside their cells. Garver must have been an easygoing sort, or just plain negligent, because one day earlier, the Pottawatomie law had wired him, warning about the possible jailbreak. He paid no attention.

At first, the break went well. Casey and the Christians pistol-whipped the jailer and ran into an alley behind the jail. There, one of the Christians—probably

Will—stole a horse belonging to police chief Milt Jones and galloped out of town. The other brother—probably Bob—and Casey fled on foot, stopped a couple in a buggy and shoved their pistols into the driver's face. Carpenter Gus White, the driver, would not let loose of the reins and managed to pull the horses to a halt. Although the fugitives shot White in the leg and stomach, he would survive.

Chief Jones was closing in on the fugitives, however, and as he got within eight or ten feet of the buggy, one of the outlaws, in the back seat, turned and shot down Jones. Some observers thought Christian killed the lawman, but the coroner's jury decided that Casey murdered Chief Jones. Whoever fired the fatal shot, the officer staggered onto the sidewalk and sank down against a building. He was dead in five minutes.

A wild gun battle then broke out on Grand Avenue between the fugitives on one side and Officers Stafford and Jackson and several armed citizens on the other. The lawmen drilled Casey through the neck and head, and the desperado died in White's riddled buggy.

Other citizens ran desperately for cover. One passerby went down with a leg wound, and a woman was slightly wounded by what the *Oklahoman* called "a spent bullet," but otherwise the local folks, except for Gus White, escaped unharmed.

Not so the shootists. In addition to Casey's fatal wound, Bob Christian was also hit but managed to run off down Grand Avenue until he met blacksmith Frank Berg, driving a cart. Christian robbed Berg of his cart, whipped up the horse and clattered off, at least until he stuck up another driver and hijacked a faster team.

With Chief Jones lying dead in the street and both of the Christian brothers vanished, Oklahoma City reacted angrily, sending a posse of "infuriated citizens" equipped with bloodhounds after the outlaws. The *Daily Oklahoman* opined that there was "little doubt" the fugitives would be captured. "Should they be caught," the paper editorialized, "a double lynching will surely follow."

That might well have happened, for the citizenry of Oklahoma City was furious. One journalist rather accurately described the Christians as "noted thugs and desperadoes," and another, having viewed Casey at the undertaker's emporium, somewhat spitefully commented that he "looked much better in death than in life." But to do the justice everybody wanted, the law first had to catch the Christians. That would prove very tough to do, though posses searched high and low.

Closer to home, the authorities soon established that a number of people had been involved in planning the break. Jessie, the loyal girlfriend,

spent fourteen months in jail for her part. Jailer Garver discovered that he should have paid attention to the warning wire. His negligence got him ten years in prison, and he served two before he was pardoned. Ironically, his incompetence would surprise nobody; the sheriff had planned to fire him on the Monday after the break.

Two other probable conspirators were arrested but never tried, and two more, John Fessenden and Louis Miller, were riding with the brothers in the newly formed Christian gang. The most surprising conspirator was W.H. "Bill" Carr, an old-time U.S. deputy marshal, whom authorities charged with supplying Bob's paramour with the very gun Carr had taken away from Bob when he took the outlaw into custody. Several "influential men" backed Carr's bond, but before his trial, Carr "gave leg bail," as the saying went, left town abruptly and was seen no more. Not so the Christian brothers. They were on the run, but they were very much in evidence across southeastern Indian Territory for the next couple of months. Even as lawmen sought their trail, the bandits embarked on a string of small-time raids on country post offices and general stores.

On July 28, the robbers held up the Wewoka Trading Company, called the "richest institution in the Seminole nation," but left with only a couple hundred dollars in "provisions and equipment" because the only man who knew the safe combination had gone home for dinner. Other raids on local stores followed, until, on August 9, the gang ran into an ambush near Wilburton. Deputy Marshal F.J., sometimes called F.C., Stockton killed Fessenden, and gang member Foster Holbrook was captured. Twelve days later, outlaw John Reeves—one of those who had furnished weaponry for the Oklahoma City jailbreak—was arrested near the town of Paoli. Later tried as a conspirator in Chief Jones's murder, he was sentenced to life.

On the twenty-third, the Christians shot their way past lawmen west of Purcell; although Deputy Marshal W.E. Hocker was wounded in the fight, the posse believed Hocker had gotten a bullet into Bob Christian. In the small hours of September 30, Louis Miller—another of the jailbreak conspirators—was jumped by lawmen near Violet Springs. Miller decided to fight and came in second.

The gang reappeared in Oklahoma County in early September, breaking into the railroad agent's quarters in Edmond. And on October 6, they held up a St. Louis and San Francisco train east of Wilburton but rode off with only another measly haul. Their last hurrah came in December, when they robbed a mining company store in Coalgate, down in Choctaw country. This raid was another poor haul: a little over $200 in money plus "goods to the value of some $200."

A month or so later, the Christian boys turned up in Seven Rivers, New Mexico, Oklahoma having become just too hot. The brothers assumed a couple of uninspired aliases and ended up in Arizona's Sulphur Springs Valley.

Bill went to work breaking horses for the 4-Bar Ranch and soon acquired the handles of "202," apparently from his weight, and "Black Jack," from his dark hair and mustache (not to be confused with outlaw Black Jack Ketchum, for whom Christian is sometimes mistaken). His partner, an honest cowboy named Ed Wilson, said of Christian that "a finer partner never lived. Big strong, fearless and good natured…ever ready to take his part, no matter what the game might be."

Black Jack loved to whoop it up over in the mining town of Bisbee, along the border, and Wilson recounted that the big puncher "could spend more money than fifteen men could earn." Black Jack often said, according to Wilson, that "he had a good idea to get up [an] outfit and go train robbing." He repeatedly urged Wilson to join him, but that honest cowpoke refused.

Others did not, however, and Christian soon raised another gang, including Texan Code (or Cole) Young, whose real name was probably Harris. Then there was Bob Hayes, who may have been another Texan, or maybe he was an Iowa hoodlum named Sam Hassels. Other gang members were Texan George Musgrave (who also called himself Jeff Davis and Jesse Johnson) and Jesse Williams (who may have been just another alias of Musgrave). Finally, add "Tom Anderson," who was probably brother Bob Christian, and you have the gang known in the Southwest as the "High Fives."

All of these ne'er-do-wells, according to cowboy Wilson, were "crack shots" who removed the triggers from their pistols and simply thumbed back the hammer "when in a tight place," fanning the pistol. "The speed," said Wilson, "with which they could shoot in this manner was simply amazing," but we don't know whether could they hit anything beyond ten feet.

With these trusty henchmen, and another hard case called "Three-Fingered" Jack Dunlap, on August 6, 1896, Black Jack robbed the bank at Nogales, right on the border. Some of his band stayed outside with the horses; the others—probably Jess Williams and Bob Hays—went into the bank. They had excellent luck at first; their mouths must have watered at the sight of some $30,000 in hard money, counted out and waiting for a rancher closing a stock purchase.

Right after that, however, things quickly began to come unstuck. According to one tale, the bank's directors were meeting upstairs. Hearing a commotion beneath, they threw open windows and opened fire on the astonished robbers. Another story says the rout of the bandits was begun

by a passing whirlwind that slammed the bank's back door and scared the gang's inside men out of a year's growth.

More probably, as other versions relate, the problem was a single tough bank man, either president John Dessert or clerk Frank Herrera. Whoever he was, he was all wool and a yard wide. Alone in the bank, he still snatched a pistol and began to blaze away. He didn't hit anybody, but his heroics were enough to drive the bandits out into the street, without their loot.

To add to their woes, either just before or just after the bank's resident hero opened fire, a passerby also pulled his .41 Colt and opened fire on the confused robbers. This was customs collector Frank King, a very tough cookie, indeed.

Whatever the sequence of things really was, it convinced the gang that Nogales was no place to tarry. The inside men tumbled out of the bank in something of a panic, dropped their loot and fled, as cowboys said, at a high lope. The bank man was still firing behind them, though all he hit was the bank ceiling and an unfortunate horse parked across the street.

Customs collector King pursued, first on a buggy horse and then on a pony requisitioned from a passing cowboy, turning back only when the outlaws began to shoot at him. Undaunted, King raised a posse and pursued again—to no avail. Other posses took the field as well, including Bisbee riders led by Burt Alvord, soon to become a bandit in his own right. Sheriff Bob Leatherwood's party, with Alvord and Cochise County sheriff Camillus Fly along, got very near the outlaws, who littered their back trail with abandoned food and cooking gear, and even a loaded mule, in their haste to reach the Mexican border. But as the posse closed in, the gang turned on them. In the ensuing firefight, one of the posse men died.

The *Tucson Daily Citizen* reported that the lawmen, led by Sheriff Bob Leatherwood, were ambushed in Skeleton Canyon. Deputy Frank Robson went down "at the first volley," with bullets through his forehead and his temple. The deputy's horse galloped off with him, dead or dying, and the waiting outlaws took not only the animal but also Robson's money, watch and revolver.

Leatherwood jumped from his horse as the panicked animal bolted. Lawman Hildreth then killed Black Jack's mount, but the bandit caught the sheriff's horse and managed to switch saddles, only to have the lawman's animal killed before Black Jack could mount.

Hildreth's horse also went down, but Hildreth, wounded, fought on, though the tree behind which he sheltered was filled with lead. Leatherwood, Fly, Alvord and another posse man named Johnson also fought back as best they could, but they were shooting only at puffs of smoke.

After the firing died away, the battered posse found their quarry vanished. The lawmen followed, reinforced by more posse men, including deadly man-hunter "Texas" John Slaughter ("I say, I say, shoot first and shout 'throw up your hands' after'").

According to one version of the tale, Slaughter was not impressed with the posse's actions thus far and said so. "I say," he commented, "you're a fine bunch of officers. If there was any ambushing to be done, why in the heck didn't you do it?"

But Leatherwood wrote from a town across in Sonora on the eighteenth that heavy rains had washed out the gang's trail, and Southern Pacific detective Billy Breakenridge reported that the robbers were back in the United States, holed up at the San Simon Cattle Company's horse ranch.

The gang struck the San Simon railroad station and both the post office and Wickersham's Store in Bowie. In between, they "liberated" horses whenever they needed new mounts, although in most cases they were careful to let the owners know where their stock was ultimately left. It paid to keep good relations with ordinary people when you were on the run—like paying for breakfast at the little Joe Schaefer ranch with several Bull Durham sacks of post office change. That sort of largesse made people feel better about you, and after all, it's not hard to be generous with somebody else's money.

The frustrated officers, including Jeff Milton, the bulldog Wells Fargo man, kept up the pursuit. Along the way, he and a deputy stayed a night at Brandt's Store in San Simon. Brandt welcomed them, since he had already been held up once by the High Fives and feared they would visit him again. And while Milton was at the store, a cowboy came in, bragging about how Christian was making fools of the officers and how he himself "could run the officers out of the country with a smoking corn cob."

It was not a wise thing to say around Jeff Milton. "Go up there," he told the deputy, "and box his jaws. I'll be a-watchin' him, and if he beats you to the draw, I'll kill him."

"Sure," said the deputy. "It'll be a pleasure." And he whopped the cowboy smartly under Milton's watchful eye. "I didn't see no smoking corn cobs," said Milton afterward.

On a moonless night in October, the High Fives hit the eastbound A&P train at Rio Puerco trestle. It should have been a pushover, for the train obligingly stopped while the engineer inspected a faulty piston rod. The gang threw down on the train crew, shooting the brakeman in the hand when he came forward to see what the trouble was. But now, bad luck appeared again in the form of a passenger: deputy United States marshal Horace Loomis.

Loomis sensed something wrong up front, so he thoughtfully loaded his shotgun and stepped quietly out into the night. He saw the engineer uncoupling the express car as Code Young shouted orders at him. Without ceremony, the officer dropped Young, who regained his feet and snapped off a couple rounds from his pistol before the marshal gave him the second barrel. Exit Code Young. The rest of the gang, uncertain what had happened to Young, at least realized that something had gone badly wrong and galloped off into the night without their loot.

The gang went on with their small-time robberies, holding up a couple of stages and a series of isolated stores. As usual, these dinky little jobs produced only pittances of money, liquor and tobacco. There was a good deal of casual brutality connected with these robberies. Bob Hayes pistol-whipped one elderly country postmaster, for example, because he objected to giving up $5.50, all the money he had.

There wasn't much profit in robbing these isolated stores, like the one in tiny Separ, between Deming and Lordsburg, New Mexico. After that strike, they ran into a posse at the Diamond A Ranch. The story goes that the gang arranged with sympathetic cowboys to display a white cloth on the corral when it was safe to visit. They hadn't counted on the law moving in and detaining everybody at the camp, spoiling the signal system. And so, when Black Jack and Bob Hayes rode into camp, all unsuspecting, the officers rose up out of their hiding place in a salt lick and blazed away.

They blew Bob Hayes off his horse, quite dead, probably killed by the rifle of town marshal Fred Higgins of Roswell (although another version of the fight says he was eliminated by a Santa Fe conductor somewhere around Kingman, Arizona). Black Jack got away from the Diamond A, even though his horse was killed by the lawmen. The story goes that Christian, single-handed, heaved the dead animal up far enough to pull his Winchester clear and then shot his way out of the ambush. A posse man had shot five times at the outlaw leader at point-blank range, but Christian escaped unscathed, largely because of the bucking and twisting of his frantic horse. Milton and the other hunters could not close with the gang. However, in February 1897, after a train robbery in New Mexico went sour, Black Jack's own paranoia moved him to kill one Red Sanders, whom he guessed had talked to the law. It was after that stupid and unnecessary murder that Christian moved south to hide out in a tangled, wild canyon, called Black Jack Canyon to this day. And in that desolate place, the law finally caught up with him.

As usual in the mythology of the West, there are a couple different stories about the end of Black Jack Christian. After the failed attempt on the A&P

train at Rio Puerco, the gang hid out at a "goat ranch" near Clifton. They planned another strike, but an informer tipped off the law before they could move. Deputy Marshal Hall, the formidable Fred Higgins, posse men Bill Hart, Crook-Neck Johnson and Charlie Paxton laid an ambush in Cole Creek Canyon, down in Graham County.

Ironically, it was a lost hat that put an end to Black Jack's career. Disappointed, the lawmen had folded up their ambush and started toward the ranch to ask for breakfast, but Fred Higgins turned back to look for his hat. At that instant, the posse saw three men on the trail behind them, already reaching for their weapons. The outlaws had not yet seen Higgins, however, and he got in the first shot. The three bandits broke for safety in the thick vegetation, but the posse saw one of them stagger before he reached cover.

The officers, accurately assessing the area as hostile and dangerous, wisely elected not to go crashing about in that heavy brush. Instead, they prudently withdrew to nearby Clifton. Later in the day, however, a cowboy named Bert Farmer passed down the same trail driving horses and stopped when the beasts shied at something near the trail.

It was Bill Christian, mortally wounded. He was taken to a nearby ranch, but he did not last long. Dying, he murmured that it didn't matter "who he was or what his name might be." A Mormon freighter brought into Clifton the bold bandit's remains, tossed on top of a load of lumber. A lot of self-appointed experts ran to identify the body, and some of them, inspired either by ignorance or friendship for the deceased, identified the body as outlaw Black Jack Ketchum.

According to Southern Pacific detective and sometime Tombstone lawman Billy Breakenridge—who managed to confuse Christian with Ketchum—an ambush party led by Deputy Sheriff Ben Clark caught Christian's gang about daylight on April 27, 1897, killing both Black Jack and gang member George Musgrave. Another source writes that only Christian went down, riddled with four slugs from the weapon of famous man-hunter Jeff Milton. Both accounts are at least probably partly wrong.

Musgrave seems to have survived the ambush in which Christian died. And Milton, a tough Wells Fargo man, was not part of the ambush party that killed Christian. Afterward, however, he ran down other High Five members, and it was Milton's shotgun that finally did in Three-Fingered Jack Dunlap, journeyman villain and veteran of the bungled Nogales fiasco.

The two bandits who got away were probably Musgrave and Bob Christian. Christian surfaced in Mexico in autumn 1897, was arrested and

escaped, then disappeared forever. Musgrave showed up later in Colorado and then got himself arrested in North Platte, Nebraska, in December 1909. He is said to have lived on in South America, dying in 1947.

One postscript remains. Black Jack Ketchum, mistaken for Black Jack Christian more than once, made an intriguing comment in April 1901, on the day he was to be hanged in Clayton, New Mexico. He knew Black Jack Christian, he said, and Christian was still alive. "Oh yes," said Ketchum, "I have an idea where he is but I won't tell." And he didn't. The secret, if there was one, went to the grave with Ketchum—both parts of him, for the shock of the drop parted him from his head, and he was buried in two pieces.

So passed the High Fives. Considering the amount of time they spent living rough and running from the law, and the nickel-and-dime scores their robberies produced, in the end, they were a remarkably unsuccessful gang of outlaws with next to nothing to show for their efforts.

Unless you consider the tally of the dead.

NED CHRISTIE

THE DOG TOWN MURDER

H e never expected that his last photograph would show him roped to his own front door, eyes half shut, holding somebody else's Winchester stuffed into his dead hands. After all, he had been a member of the Cherokee National Council, the equivalent among his people of a United States senator. He was a six-foot-four giant in an era when most men were ten inches shorter. He was ruggedly handsome, even in death, despite being blinded and scarred by lawmen's bullets. But five years earlier, on a Wednesday in early May 1887, everything had changed for Ned Christie at a makeshift log bridge across Spring Branch Creek.

Back then, on a bright moonlit night, deputy U.S. marshal Dan Maples and his posse man George Jefferson were in Tahlequah, Indian Territory, looking for booze. And they weren't thirsty. Maples had learned that two whiskey peddlers, Thomas "Bub" Trainor and Trainor's crony, John Parris, were in Dog Town, a sizeable sin zone on the north side of Tahlequah. The lawmen meant to execute warrants that "the Hanging Judge" Isaac Parker had just issued in Fort Smith.

The marshals discovered that Trainor (whom some sources called "Bud") and Parris were dining in the home of Nancy "Old Lady" Shell, who, like her contemporary Belle Starr, apparently considered herself a friend of any bold and courageous outlaw. Armed with this intelligence, Maples made a long-distance call from the newfangled telephone installed in the John S. Stapler general store just a year earlier to report his findings. And one of Bud Trainor's cronies heard everything.

"Don't shoot!" Maples or Jefferson yelled minutes later, for all the good it did them. Maples got off a few rounds as the bullets hit his chest, but the shooter in the trees across the creek got away, as a figure nearby silently watched the whole thing. Somehow, Jefferson escaped injury, but Maples died just after midnight without naming his killer.

That morning, on May 5, the law officers found the neck of a whiskey bottle and a piece of cloth next to the tree from which Jefferson said the assassin had fired. Nearby, the rest of the bottle was soon discovered—in the pocket of a jacket that locals said belonged to Ned Christie.

Ned was born not far from Tahlequah in Rabbit Trap eight years before the Civil War began. His father, Watt Christie, was a blacksmith who had been in the minority faction among the Cherokee that had sided with the Union. Watt was also an astute politician. Three of his sons eventually followed their father into tribal leadership.

Ned became a gunsmith and began serving on the Cherokee National Council in 1885, although he had killed another Cherokee the prior year in an alcohol-fueled brawl. Ned had been acquitted after a murder trial.

He immediately made a name for himself as a hot-tempered champion of national sovereignty who opposed the railroad incursions and the imminent tribal land allocations to individual Cherokees that some of his opponents called progress.

Two years later, the Cherokee Female Seminary, the first advanced education institution for women established west of the Mississippi, inexplicably burned to the ground on Easter Sunday in April 1887. The National Council was convened to determine what could be done. And that brought Ned to Tahlequah.

Despite his responsibilities, Ned spent his time there with a bad crowd. And sometime whiskey peddler John Parris was one of his Tahlequah cronies. On the evening of Wednesday, May 4, Parris and Christie went to the Nancy Shell house, on the north side of the Spring Branch Creek in Dog Town. She sold them a bottle of whiskey, using a piece of cloth ripped from her apron as a cork. Nearby, in the same house, the miscreant Bub Trainor tucked in for a solid dinner.

When he woke up the next morning, Ned discovered he was a murder suspect. The last thing he remembered was drinking with Parris and two others near the creek, a favorite campout spot for boozers who couldn't or wouldn't pay for a night's lodging. Some say Ned Christie received conflicting advice from Cherokee leaders. His own father, Watt Christie, may have advised him to stay and face the charges, while all accounts agree

that Cherokee senator Ned Grease said that he should leave town. In some accounts, Christie insisted that he didn't even have a gun with him that night. He stayed until the following Monday, May 9 and attended the opening of the National Council but then disappeared. He may have learned on Tuesday, May 24, when the National Council Session ended, that he was to be arrested.

Indeed, shortly after the May 5 Maples murder, arrest warrants had been issued in Fort Smith for Ned Christie, John Parris, Bub Trainor, Charley Bobtail and George Parris. All versions of these events agree that when Ned learned about this, he quickly returned to Rabbit Trap, his home some twelve miles east of Tahlequah, near present-day Eldon.

Cherokee high sheriff John Hawkins mortally wounded Bud Trainor's father on June 20 during a gunfight in Tahlequah over the charges against Bud.

Oklahoma lore based on late-life interviews says that after his July 23 murder indictment, along with John Parris, Bub Trainor, Charley Bobtail and George Parris, Christie sent a message to Judge Isaac Parker in Fort Smith asking for bail, which Parker declined. Similar stories have Christie going through Cherokee religious rituals even as his family and friends in the secret Keetoowah Society organized a series of informers to sound the alarm when federal authorities came for him.

That summer, John Parris and Bobtail languished in the jail beneath Judge Parker's courtroom in conditions so miserable that the place was called Hell on the Border.

Trainor had been on the run since the May 1887 Maples murder. A Fort Smith newspaper reported that his "gang" had tangled with the Vann gang on September 25 on Fourteen Mile Creek, near Fort Gibson. More certainly, he was formally charged with the October 8 robbing and burning of a store in Oaks, north of Tahlequah, before finally being arrested on the Maples murder charge in mid-November 1887.

John Parris turned state's evidence after a July 20, 1888 hearing, claiming that he had seen Ned Christie kill a deputy U.S. marshal after an argument. A black freedman named Dick Humphrey was eventually added to the witness list.

That summer of 1888, in some accounts, deputy U.S. marshals tried to arrest him, but Ned had a commanding view of the approaches to his cabin and injured both of them.

Three months after the Maples killing, on August 1, 1887, Ned and his father, Watt Christie, both lost their seats on the National Council,

even as support grew for the individual Cherokee land allotments both men opposed.

Christie was indicted in a Cherokee court on March 5, 1888, with two others for the Sunday, February 19 killing of Bear Grimmet, a Cherokee outlaw and bootlegger who had swiped Ned Christie's illegal shipment of whiskey at a place called Bunker Station.

Trainor appeared in the Maples matter on March 25, 1888, and claimed in May 1888 that, while Maples was killed, he was having supper at the Nancy Shell place; in fact, Nancy "Old Lady" Shell and two others could testify accordingly, or so Trainor's lawyer claimed. Yet by the last day of 1888, Clem V. Rogers, father of Will Rogers, and other Cherokees posted his bail, clearing the way for the accused arsonist to become a deputy U.S. marshal. Parker never commented explicitly about this appointment but once stated that he was "obliged to take such material for deputies as proved efficient in serving the process of this court."

Five months later, in May 1889, Union army veteran Jacob "Blake Jake" Yoes was appointed U.S. marshal for the Western District of Arkansas, which included Indian Territory. Yoes made arresting Ned Christie a top priority and appointed his best deputy, former Confederate Henry A. "Heck" Thomas, to bring Christie in. Yoes reminded Thomas about the $500 reward for Christie (some $12,000 in modern money) and sent him to Rabbit Trap.

Along the way, Thomas and his fellow marshal L.P. Isbell of Vinita collected about a dozen other prisoners before arriving in Muskogee, where they met newly minted deputy U.S. marshal Trainor, against whom an indictment in the Maples murder was still pending.

The next morning, on Thursday, September 26, 1889, the dogs howled, and Christie climbed into his loft, loudly sounding the Cherokee death gobble as the posse approached, despite having told a neighbor recently that he was thinking about giving himself up. When rushing the fugitive's cabin didn't work, they burned the privy but held their gunfire as Nancy Christie ran out, just as Deputy Marshal Thomas directed.

The cabin fell silent at last after Christie's young son James was shot in the back but somehow escaped. Since Thomas now assumed that everyone left inside was dead and Deputy Isbell was bleeding profusely from a shoulder wound, the posse returned to Fort Smith, not knowing that Ned Christie was blind in one eye, disfigured for life but alive.

His neighbors found Ned before the cabin burned to the ground. Dr. Bitting, who ran a gristmill nearby, treated Ned and James Christie while many of the same neighbors and others constructed Ned's Mountain, a

hilltop stronghold still visible as late as 1990 about a half mile west of the destroyed cabin.

According to the *Muskogee Phoenix*, Thomas claimed that "Christie is known to have killed eight men in his time, four of whom have been killed since the shooting of Marshal Maples." Some versions of events have Ned becoming an outlaw who robbed area stores and challenged Heck Thomas to "come get him." Heck didn't try to do that, but on Tuesday, November 12, he scouted the new fort with a posse that included Bub Trainor and decided to fight another day.

Ned hid with his family in plain sight as the decade opened. U.S. Marshal Yoes became more and more frustrated as 1891 passed, while Ned Christie began to hear that he had committed every robbery and murder in the Cherokee Nation, like Pretty Boy Floyd, Dillinger and Bonnie and Clyde some forty-two years later. Even Ned's neighbors spoke of him then, and later, as an outlaw and bootlegger who robbed stores for miles around. That said, robbery charges against Ned Christie have never surfaced, although a single horse theft accusation in the Cherokee Nation was eventually dropped. Still, a $1,000 reward was offered for the capture of Ned Christie on October 15, 1891. Now it was a matter of time.

Stories of deputy U.S. marshals and others chasing Ned Christie through the Cookson Hills of present-day eastern Oklahoma abound, but if it happened at all, nothing concrete came of it. Deputy U.S. marshal David Rusk intended to change all that a year after the reward was offered.

Ned knew that the United States authorities were coming and transformed his burned-out cabin into a two-story fortress that soon would be tested. On the morning of Wednesday, October 12, 1892, a three-man posse sent by Rusk placed some dynamite against Ned's Fort, only to watch the fuse burn out. Twenty-four hours later, the posse called it a day. Back in Fort Smith, U.S. marshal Blake Jake Yoes decided it was time for a different approach.

An eleven-man posse supplemented by some six more volunteers along the way left Fayetteville, Arkansas, on November 2 for Rabbit Trap, led by posse man Gus York, who knew the Christie neighborhood quite well. The posse was under the nominal leadership of deputy U.S. marshal Gideon S. "Cap" White, a Union cavalry veteran from East Tennessee. Deputy marshals Dave Rusk and Charley Copeland met them at the Arkansas border. Cherokee high sheriff Benjamin Knight came along to translate posse commands into Cherokee.

Since Ned Christie wasn't scared of bullets, the posse requested that a cannon be shipped to them from an army post in Kansas. They traveled on

through the night, reaching Rabbit Trap at four o'clock the next morning. But something was wrong; the dogs that had warned Ned about earlier attacks were gone.

While the posse discussed whether Ned was inside the fort, "Little Arch" Wolf came out of the house shortly after daylight, refused to surrender and ran back into the house, despite three gunshot wounds. Soon, the posse asked Ned in Cherokee to surrender, and after a gobbling battle cry, he allowed three women to leave as the posse suggested, leaving Ned, Charles Hare, Little Arch and a seven-year-old named Charley Grease to finish the fight. Eventually, a crowd that included the Christie women and Ned's father, Watt, gathered nearby. Watt, who waited with them, refused to ask his son to surrender, telling the posse that he "could see no evil in his son."

When the small cannon arrived from Kansas at about one o'clock, the posse positioned it on a tree stump and fired into Ned's Fortress thirty-eight times without effect. Shortly after dark, the posse decided to use Christie's own wagon as a makeshift siege tower, which two volunteers used to place a dozen or more sticks of dynamite against Ned's Fort while the rest of the posse poured gunfire into the opposite side of the fort.

Later, some claimed that the explosion could be heard in Tahlequah; the dynamite blew Ned's Fort apart and started a fire from top to bottom. Little Charley Grease and Ned Christie retreated to the root cellar after the explosion. And soon, Ned crawled out and began shooting as he ran toward the posse. He gave Wes Bowman a dark powder burn on his face that Bowman wore for life. But after Bowman and other posse members shot Ned Christie to death, peace descended on Rabbit Trap. One of the shooters was Sam Maples, son of the murdered deputy U.S. marshal. And even then, before daybreak, the mourning Cherokee women began to trill.

The posse captured young Charley Hare as he tried to escape from Ned's Fort. Hare spent three years in prison for his part in the standoff. Little Arch, initially reported to have died in the Ned's Fort fire, was arrested a year later and released from prison in 1903. Both Hare and Wolf were convicted of assault with intent to kill.

The Christie family fared even worse in the years that followed. Ned's son James was attacked and decapitated in July 1893, even as Ned's brother Bill languished in the jail at Watonga, waiting to be hanged. Ned's old drinking buddy Bub Trainor was not around to see any of this happen.

Bub had continued his law enforcement career just long enough to doze in a drunken stupor through a gunfight between deputy U.S. marshal Bob Hutchins and outlaw Jim July Starr on January 23, 1890. And with that, he

returned to bootlegging and perhaps even robbery before being shot dead on Christmas night 1896.

Dick Humphrey, a former Cherokee slave and the Maples murder witness named back in July 1888, never testified under oath. But in an interview the *Daily Oklahoman* published on June 9, 1918, long after Bub Trainor was dead, at age eighty-seven, Humphrey told a reporter what he had seen on Big Spring Creek from the Dog Town side, thirty-one years earlier.

Humphrey claimed in the interview that under a bright full moon, from a downstream vantage point nearby, he had watched Bub Trainor approach Christie, who was asleep with some other drunks. Trainor took off Christie's coat, put it on over his own white shirt and shot deputy U.S. marshal Maples from ambush, as Humphrey watched from hiding.

Although no one knows for certain, most modern historians who have examined the case have expressed the view that whatever his other crime, Ned Christie was all but certainly innocent of the Dog Town murder.

SELECTED BIBLIOGRAPHY

Adams, Ramon. *Burs Under the Saddle: A Second Look at Books and Histories of the West*. Norman: University of Oklahoma Press, 1964.

Anderson, Dan, with Laurence J. Yadon and Robert Barr Smith. *100 Oklahoma Outlaws, Gangsters and Lawmen, 1839–1939*. Gretna, LA: Pelican Publishing Company, 2007.

Burrough, Bryan. *Public Enemies: America's Greatest Crime Wave and the Birth of the FBI, 1933–1934*. New York: Penguin Press, 2004.

Burton, Jeff. *Black Jack Christian*. Santa Fe, NM: Press of the Territorian, 1967.

Butler, Ken. *Oklahoma Renegades: Their Deeds and Misdeeds*. Gretna, LA: Pelican Publishing Company, 2000.

Coffeyville, Kansas Journal, October 7, 1892.

Coroner's Report. Los Angeles Medical Examiner-Coroner, No. 76-14812.

Daily Oklahoman (Oklahoma City). "Bandit Slain in Desperate Fight with Officers." September 8, 1911.

Daily Times-Journal (Oklahoma City), August 22, 1895.

Dalton, Emmett. *Beyond the Law*. Coffeyville, KS: Coffeyville Historical Society, n.d.

Denver Post. "Train Robber Died to Get into Show Business." September 10, 1989.

Dodge, Fred. *Under Cover for Wells Fargo*. Edited by Carolyn Lake. New York: Ballantine, 1968.

Edmond, Oklahoma Sun Democrat, July 5, 1895.

Elliott, David Stewart. *Last Raid of the Daltons and Battle with the Bandits at Coffeyville, Kansas, October 5, 1892*. 1892. Reprint, Coffeyville, KS: Coffeyville Journal, n.d.

Farris, David A. *Oklahoma Outlaw Tales*. Edmond, OK: Little Bruce, 1999.

Foreman, Grant. *The Five Civilized Tribes*. Norman: University of Oklahoma Press, 1989.

Graves, Richard S. *Oklahoma Outlaws: A Graphic History of the Early Days in Oklahoma; the Bandits Who Terrorized the First Settlers and the Marshals Who Fought Them to Extinction; Covering a Period of Twenty-Five Years*. Oklahoma City, OK: State Printing & Publishing Company, 1915.

Hamilton, Stanley. *Machine Gun Kelly's Last Stand*. Lawrence: University of Kansas Press, 2003.

Hanes, Colonel Bailey C. *Bill Doolin, Outlaw O.T.* Norman: University of Oklahoma Press, 1968.

Harmon, S.W. *Hell on the Border: He Hanged Eighty-Eight Men*. Muskogee, OK: Indian Heritage Association, 1971.

Hazel Chapman interview. Skiatook, OK. *Coffeyville Journal*, October 2, 1891.

Hogan, Lawrence J. *The Osage Indian Murders*. Frederick, MD: Amlex, Inc., 1998.

Karpis, Alvin, with Bill Trent. *The Alvin Karpis Story*. New York: Coward, McCann and Geoghegan, Inc., 1971.

Koch, Michael. "Zip Wyatt: The Cherokee Strip Outlaw." *Oklahombres Journal*, May 23, 2000.

Kohn, George C. *Dictionary of Culprits and Criminals*. Metuchin, NJ: Scarecrow Press, 1986.

Lavone, Luby. "Desperado: The Infamous Belle Starr." www.geocities.com/laverne/outlaws.

Indian-Pioneer Papers. Interview with Jim McLish. University of Oklahoma Western History Library.

————. Interview with Ike Nicholson. University of Oklahoma Western History Library.

————. Interview with R.B. Schooley. University of Oklahoma Western History Library.

————. Interview with Jennie Watts Cantelou. University of Oklahoma Western History Library.

"Letter from Clyde Barrow to Henry Ford praising the Ford V-8 car, 1934." Online Collection, the Henry Ford Museum. www.theHenryFord.org.

Literary Digest, April 23, 1926.

Milner, E.R. *The Lives and Times of Bonnie and Clyde*. Carbondale: Southern Illinois University Press, 1996.

Morgan, R.D. *The Bandit Kings of the Cookson Hills*. Stillwater, OK: New Forums Press, 2003.

Murray, David. "Al Spencer & Gang." Oklahombres. www.oklahombres.org.

Nix, Evett Dumas. *Oklahombres: Particularly the Wilder Ones*. Lincoln: University of Nebraska Press, 1993.

Police Department, City of Long Beach, California. Dead Body Report 7650028.

Poulsen, Ellen. *Don't Call Us Molls: Women of the John Dillinger Gang*. Little Neck, NJ: Clinton Cook Publishing Corp., 2002.

Preece, Harold. *The Dalton Gang: End of an Outlaw Era*. New York: Hastings House, 1963.

Rascoe, Burton. *The Dalton Brothers: By an Eyewitness*. New York: Frederick Fell, 1954.

Samuelson, Nancy. *The Dalton Gang Story: Lawmen to Outlaws*. Eastford, CT: Shooting Star Press, 1992.

————. *Shoot from the Lip*. Eastford, CT: Shooting Star Press, 1998.

Shirley, Glenn. *Belle Starr and Her Times*. Norman: University of Oklahoma Press, 1982.

————. *Heck Thomas, Frontier Marshal*. Norman: University of Oklahoma Press, 1981.

————. *Last of the Real Badmen: Henry Starr*. Lincoln: University of Nebraska Press, 1976.

————. *Law West of Fort Smith: A History of Frontier Justice in the Indian Territory*. Lincoln: University of Oklahoma Press, 1968.

————. *Temple Houston: Lawyer with a Gun*. Norman: University of Oklahoma Press, 1980.

————. *West of Hell's Fringe: Crime, Criminals and the Federal Peace Officer*. Norman: University of Oklahoma Press, 1978.

Smith, Robert Barr. "Born Bad: The Outlaw Christian Brothers." *Wild West* (December 2000).

————. *Daltons! The Raid on Coffeyville, Kansas*. Norman: University of Oklahoma Press, 1996.

————. "Shootout at Ingalls." *Wild West* (October 1992).

———. *Tough Towns: True Tales from the Gritty Streets of the Old West*. Guilford, CT: Globe Pequot Press, 2007.

Snow, Clyde. "The Life and Afterlife of Elmer J. McCurdy: A Melodrama in Two Acts." In *Human Identification: Case Studies in Forensic Anthropology*. Springfield, IL: Charles C. Thomas, 1984.

Speer, Bonnie Stahlman. *The Killing of Ned Christie*. Norman, OK: Reliance Press, 1990.

Starr, Myra Maybelle Shirley. Handbook of Texas Online. www.tsha.utexas.edu/handbbokonline.

Steele, Phillip. *The Last Cherokee Warriors*. Gretna, LA: Pelican Publishing Company, 1974.

———. *Starr Tracks: Belle and Pearl Starr*. Gretna, LA: Pelican Publishing Company, 1989.

St. Louis Globe-Democrat, October 17, 1892.

Wallis, Michael. *Pretty Boy: The Life and Times of Charles Arthur Floyd*. New York: St. Martin's Press, 1992.

Wall Street Journal. "A Corpse Is a Corpse, Of Course, Unless It's Elmer McCurdy." July 11, 1991.

Winter, Robert. *Mean Men: Sons of Ma Barker*. Danbury, CT: Rutledge Books, 2000.

Yadon, Laurence J. "The Gangs of Frontier Tulsa." *Wild West History Association Journal* (April 2009).

———. "Tigress: The Life and Times of Kathryn Kelly." *This Land Press*, October 15, 2011.

INDEX

INDEX

ABOUT THE AUTHORS

Robert Barr Smith, a commentator and published authority on military history and legal writing, is a professor emeritus at the University of Oklahoma College of Law. Smith, a retired U.S. Army colonel, lives on Missouri's Table Rock Lake.

Laurence J. Yadon is an attorney, mediator and arbitrator with a lifelong interest in Oklahoma and criminal history. Yadon has investigated litigation issues for the Department of Justice and helped prepare a case successfully argued before the Supreme Court. He lives in Tulsa, Oklahoma.

Smith and Yadon have coauthored eight books and individually published numerous articles about law and American history.